BLACKPOOL
THROUGH TIME
A SECOND SELECTION
Allan W. Wood

AMBERLEY PUBLISHING

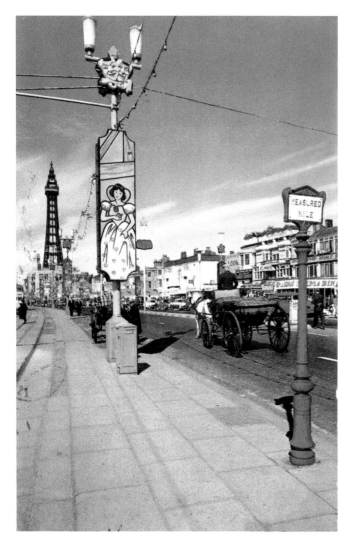

This page: The Golden Mile in the 1960s.

On the cover: Tower and Big Wheel looking west from Adelaide Street.

First published 2012

Amberley Publishing
The Hill, Stroud
Gloucestershire, GL5 4EP

www.amberley-books.com

Copyright © Allan W. Wood, 2012

The right of Allan W. Wood to be identified as the Author of this work has been asserted in accordance with the Copyrights, Designs and Patents Act 1988.

ISBN 978 1 4456 0528 9

British Library Cataloguing in Publication Data.
A catalogue record for this book is available from the British Library.

Typeset in 9.5pt on 12pt Celeste.
Typesetting by Amberley Publishing.
Printed in the UK.

Introduction

The changes in social freedom and mobility over the last two centuries fuelled Blackpool's rapid development (and the adjoining towns) and changed the landscape from a scattering of farms and small villages along Lancashire's Fylde coast into a dense urban coastal sprawl, now largely dependent upon the leisure and travel industries for its prosperity. That Blackpool grew to become the UK's premier holiday resort and has retained this position is primarily due to the seven miles of wide sandy beach, the often bracing west-facing sea frontage and its proximity to the industrial towns and working-class people of the north of England, as well as the unique development of attractions and facilities aimed at letting people have fun.

However, Blackpool would not have developed without the foresight and enterprise of those who oversaw the building of the town in its early years and those who sought to capitalise on the increasing affluence and freedoms of the working classes in the nineteenth and twentieth centuries, together with the accessibility of the town on the opening of train lines into Blackpool in the 1840s (Talbot Road Station) and 1860s (South and Central stations). The Tower, its Circus and Ballroom, the three piers, electric trams, the Winter Gardens, the wide promenades and sea defences, the Golden Mile, the Illuminations, the Pleasure Beach, as well as the now demolished Big Wheel, Palace Theatre and South Shore Open Air Baths, are examples of the attractions that ensured Blackpool became a world-famous holiday resort and now help to sustain it in these more difficult times.

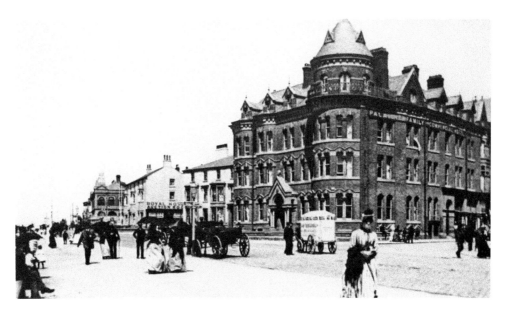

The Promenade looking north from the Palatine Hotel in the late 1880s.

Blackpool's heyday was probably in the post-war years, when tens of thousands would travel by train to North or Central stations for a day out or a week's family holiday in a 'bed & breakfast' boarding house. However, despite the M55 motorway link, the town has suffered since the evolution of cheap package holidays in the late 1960s and our desire for a holiday with guaranteed sunshine rather than the varied weather of an English summer.

Blackpool will always have its glorious natural assets – the 'golden sands and sea views'. It continues to develop, rebuild and re-package itself as a holiday resort. Examples of this are the expanded Hounds Hill Centre, the extensive town centre improvements, the excellent promenade works between North Pier and Harrowside to the south, which are now complete, along with the Tower Headland and the complete overall and renewal of the tramways and tramcars.

Acknowledgements

The author would particularly like to thank Ted Lightbown, Chris Bottomley, Nick Moore, Phil Barker, Ray Maule, Michelle Wood, Blackpool Central Library, Tramcards, The E. J. Boys Archive, the Blackpool Postcards website, Paul Bonsor, Andy Gent, Elaine Higgins, The *Evening Gazette*, Genuki, Bill Dainty, Mary Murray, Steve Palmer and Brian Turner, and Melanie Silburn for the photograph of Oddfellow Street taken by her late father, the Blackpool historian Allan Stott.

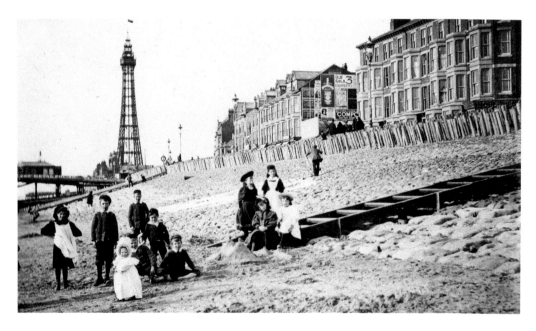

Promenade looking north from just south of Central Pier in the 1890s.

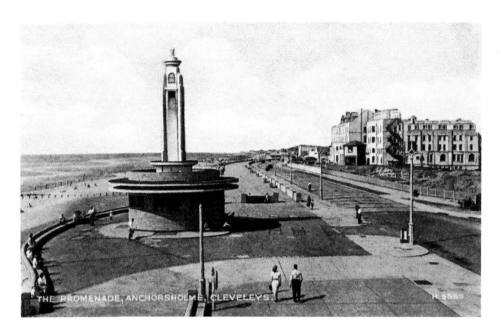

Anchorsholme Promenade

The northern boundary of Blackpool was extended to just north of Cleveleys Hydro in 1918. Sea wall works from Bispham to Cleveleys commenced in August 1932 and were completed in 1937. The 100-foot wide section north of Little Bispham named Princes Way was constructed on the shingle foreshore and a pumping station serving the sea outfall was built below the Promenade on the line of the main sewer in Anchorsholme Lane. The art deco-style pumping station entrance building was demolished in the early 1980s when the sea outfall was lengthened and a new entrance was built in the north-west corner of Anchorsholme Park.

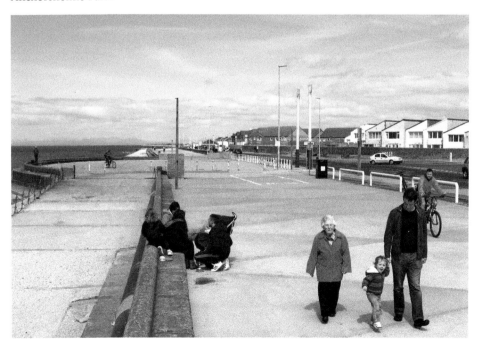

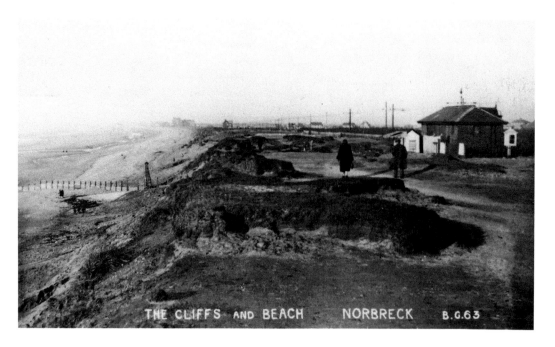

The Cliffs at Norbreck

The sand cliffs at Norbreck were protected to a degree by the gravel foreshore but erosion of the cliffs elsewhere in the north of Blackpool was said by Borough Engineer Henry Banks to have been recorded as '2 yards per year' during the thirty years prior to 1917. The building to the right is thought to be the tram station of the Blackpool & Fleetwood Tramroad opposite Norbreck Road and the 'slade' to the beach. The building in the far distance is Cleveleys Hydro.

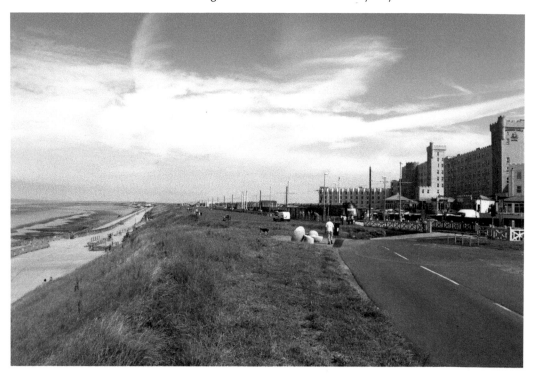

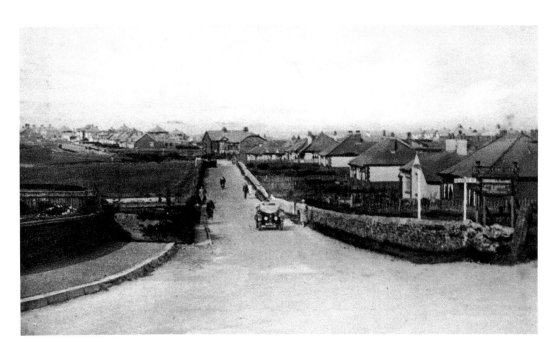

Norbreck Road

The land to the left of this late 1920s postcard view near the junction with Guildford Avenue is part of the Norbreck Hall Hydro eighteen-hole golf course which was also partly to the south of Norbreck Road. The land to the left was built upon in the 1950s and '60s and is now Kirkstone Drive, Westbury Close, Elmbank Avenue and Waterhead Crescent. In the distance to the right is Mossom Lane. There are no footpaths at this time on Norbreck Road but luckily there are few cars either.

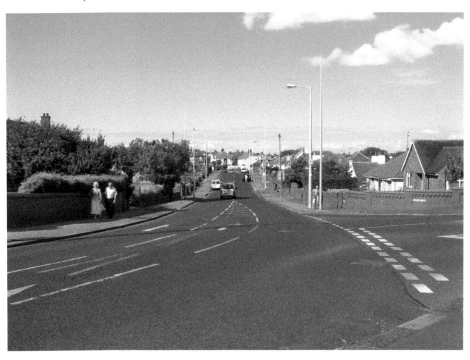

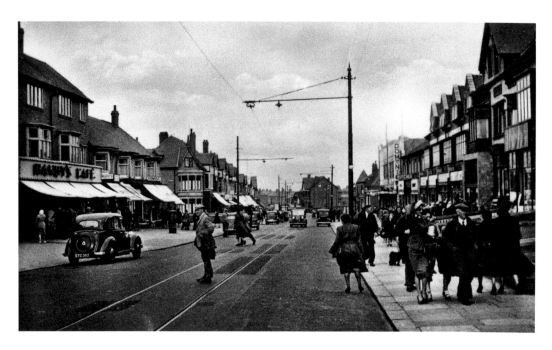

Red Bank Road, Bispham

A busy Red Bank Road is seen here in the 1950s. The houses on either side of the road originally had gardens and have all been converted to shops and cafés to cater for the growing population of Bispham and the busy tourist season. The Dominion Cinema can be seen to the right and Bispham Conservative Club is in the distance in the centre. The tram track led to Bispham Tram Depot, which closed in 1963 and was used by Alpic as a supermarket and is now Sainsbury's car park.

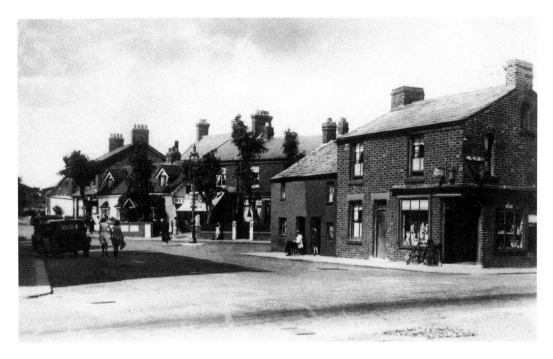

Bispham Village

This is a view of a serene Bispham Village in the early 1930s looking west. To the right is the old post office on the corner of All Hallows Road and Red Bank Road, which was demolished in 1937 and was a traffic island for many years before the whole area was redeveloped into a modern shopping centre and car park in the 1960s. In the background is Ivy Cottage as a café, its roof tiled and without its barn.

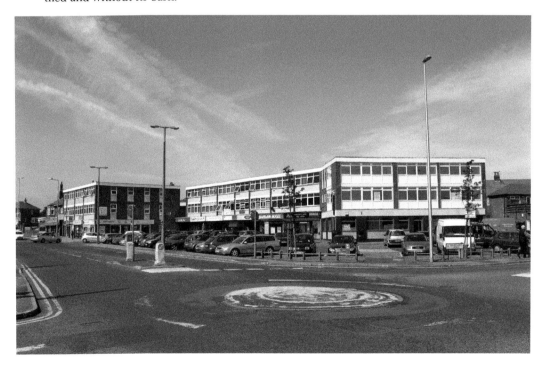

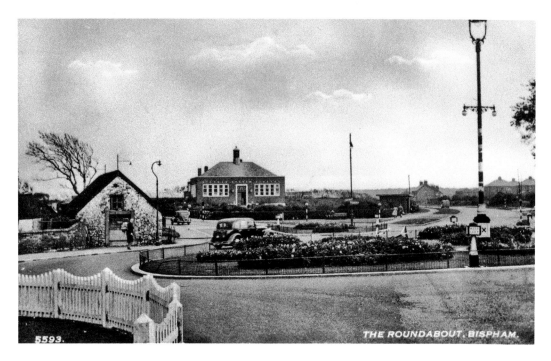

Bispham Roundabout

The earlier view is a postcard view looking south towards Bispham Road and Devonshire Road in the 1940s. In the centre is Bispham Library, which opened on 5 May 1938. Bispham Police Station was built in the 1960s in the garden of the cottage and barn to the left. Before the rise of the motor car this would have been a view looking south across Red Bank Road from Bamber's Farm with the Bethel Chapel (closed in 1912) in the centre, just south of the roundabout. At that time the Bispham end of what is now Devonshire Road was named Tiddicar Lane.

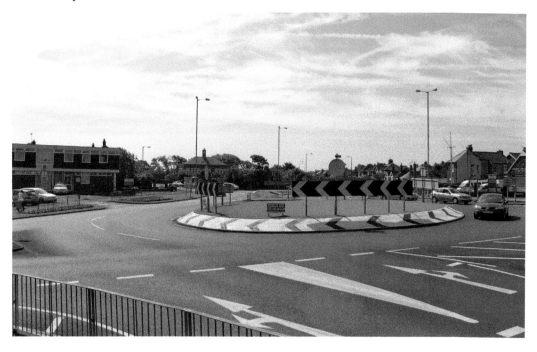

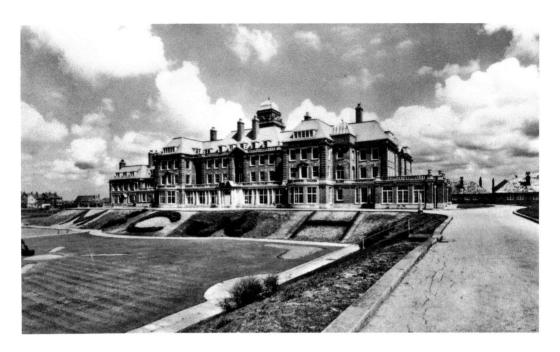

The Miners' Convalescent Home

The impressive Miners' Convalescent Home on Queen's Promenade is a Grade II listed building and was opened on 28 June 1927 by HRH Edward Prince of Wales. Built in red and light brick with terracotta dressings in the Baroque Revival style with three floors and an attic, the convalescent home for Lancashire and Cheshire miners was open until the 1980s and was converted in 2005 into forty-seven apartments, with two new detached, multi-storey wings added in the grounds. The property is now named Admiral Point.

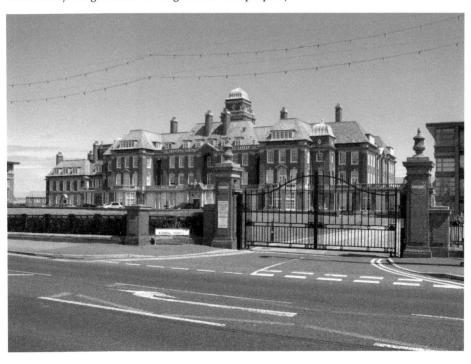

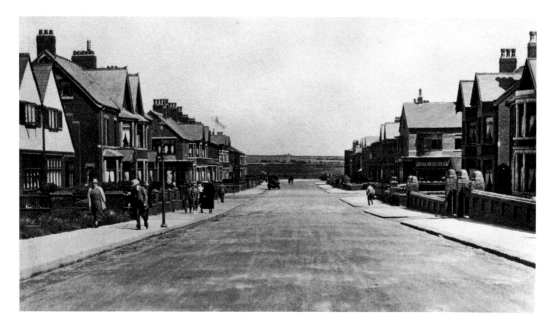

Shaftesbury Avenue

This area of Blackpool (north of Empress Drive) was in the Urban District of Bispham with Norbreck until 1918 when the northern boundary of the borough was extended. The Gynn Estate Company Limited had been formed in May 1897 and the development of hotels on Queen's Promenade and residential properties in a grid-like layout east to Devonshire Road and north to Bispham soon took place. This view (*c.* 1920) looking east down Shaftesbury Avenue across Holmfield Road shows that the land east of Warbreck Drive was still part of North Shore Golf Club (formed on 15 March 1904) before the land south of what is now Shaftesbury Avenue to Warbreck Hill Road was sold to the Borough on 31 December 1925.

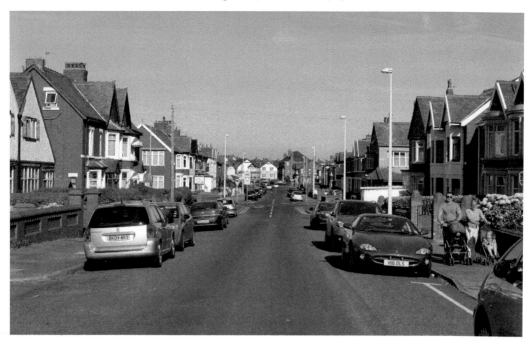

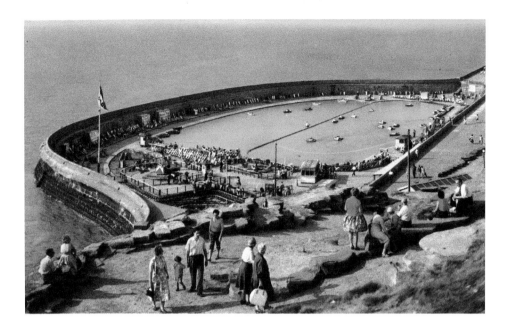

The Boating Pool, North Shore

Originally intended as an open-air baths, the sea wall works to the Boating Pool were completed in 1921. The Cabin Lift was added in 1930 and is a Grade II listed building. The Boating Pool was run successfully by the Maxwell family from the 1920s to the mid-1970s, until the change in the requirements of holidaymakers and severe storms that caused much damage to the sea defences made it difficult for it to be commercially viable. The sea wall reconstruction works to the Boating Pool of the mid-1980s reduced the size of the boating area and it is now a go-kart track. The somewhat unnatural outcrop of concrete and rendered rubble on the cliffs at this location was a necessary preservation measure.

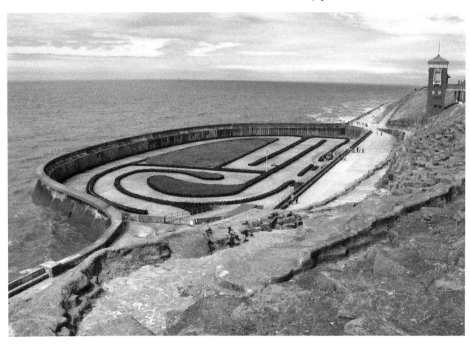

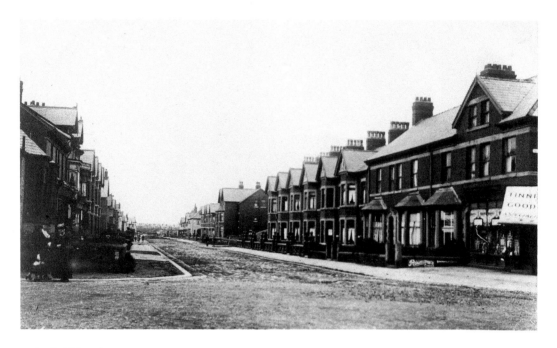

Holmfield Road

Originally named Holmecliffe Road, Holmfield Road is seen here at the junction of Knowle Avenue looking towards Bispham, with the road and houses only constructed to just north of Carlin Gate. In order to retain the upmarket standing of this area the Gynn Estate Company placed restrictive covenants on the properties north of Warbreck Hill Road and the shops at this junction are the only shops between the Queen's Promenade/Devonshire Road and Bispham. The building on the left corner is now a paper shop, previously owned by the Bonsor family for many years – though it was located next door for a long period. On the right, the general store was later an electrical and fancy goods shop and is now Cohen's chemist.

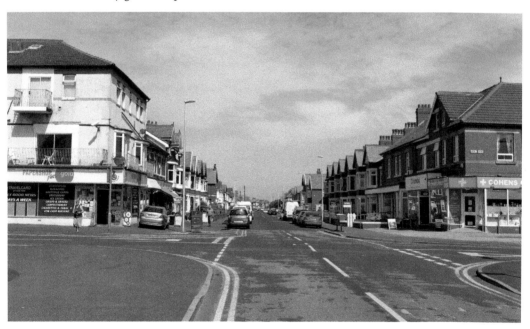

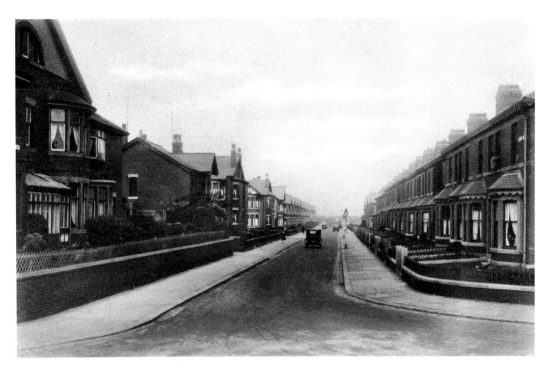

Cornwall Avenue

Looking north up a part-developed Cornwall Avenue from the junction with Warbreck Hill Road in the early 1920s. The clubhouse of North Shore Golf Club and the golf course itself is at this time just past the row of houses to the right at No. 62. The property was occupied by the Deaf Institute for many years, with a bar and snooker facilities until September 2011, and is now used for meetings. Note the man sitting on the window ledge at No. 2.

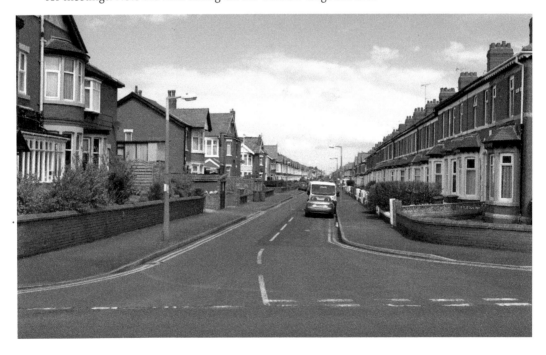

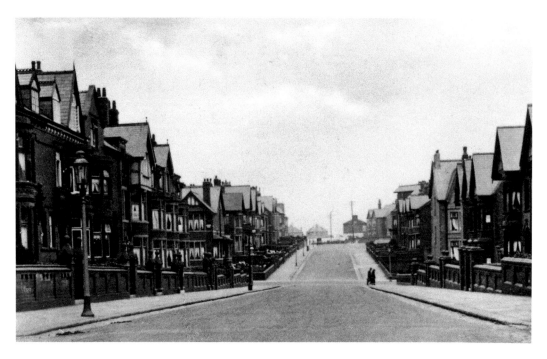

King George's Avenue

The development of the Gynn Estate generally spread north from Warbreck Hill Road in the early 1900s and an extremely quiet King George's Avenue is seen here in the 1920s. The properties, like those in the other surrounding roads, were built in the slightly 'upmarket' Blackpool style – double bay windows to the front with red Accrington ('Nori') engineering brick. Just behind this view is the Savoy Hotel and Grade II listed Savoy Garage. In the distance, building work to the south side of Warbreck Hill Road is in progress.

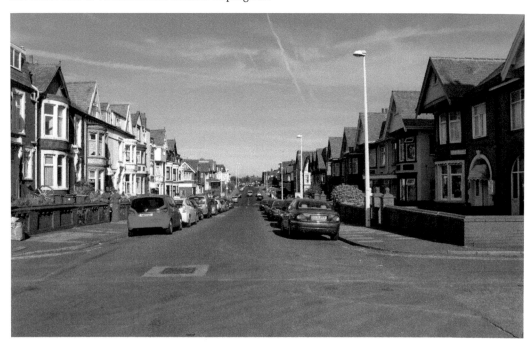

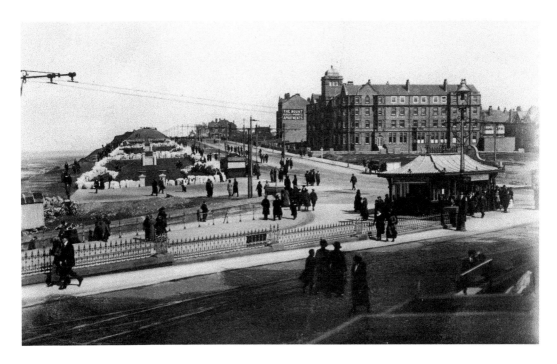

Looking North from Gynn Square, *c.* 1915

The Gynn and the early days of Queen's Promenade to the north are seen here around 1915. At this time the Blackpool Corporation Tramway terminated at Gynn Square while the separate Blackpool & Fleetwood Tramroad, which first opened on 14 July 1898, ran from Talbot Road Station along Dickson Road *en route* to Bispham and Fleetwood. Blackpool Corporation purchased the tramroad to Fleetwood in 1920. The Savoy Hotel opened in 1915 and the formal sunken gardens to the west of the tramway were completed that year. The Cliffs Hotel was built in 1921 as the Brynn Tivy Hotel, changing its name in 1929, and was enlarged in 1936/37.

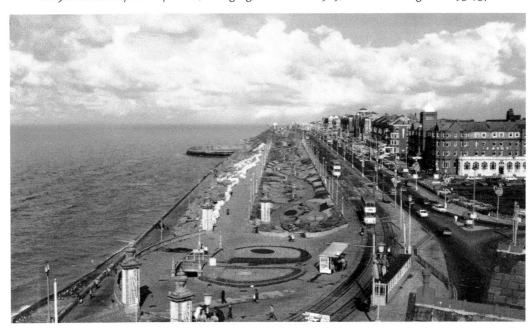

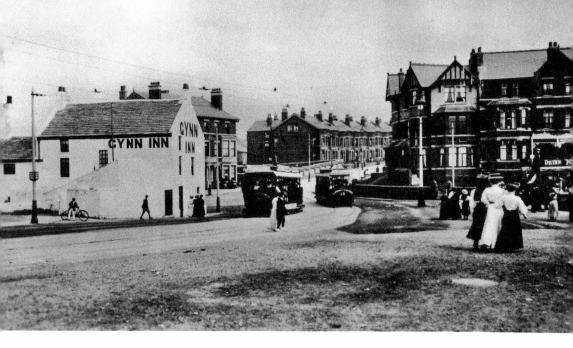

Gynn Square and Dickson Road, *c.* 1907

The Gynn Inn had been one of Blackpool's earliest accommodation houses and inns, dating from the late eighteenth century, and was located in the area of what is now the large roundabout at the northern end of Dickson Road (previously Warbreck Road) and the Promenade. It closed on 2 May 1921 and was demolished to make way for road improvements. Behind the Gynn Inn is the Duke of Cambridge Hotel, built in the 1860s and replaced by the Gynn Hotel in the 1930s.

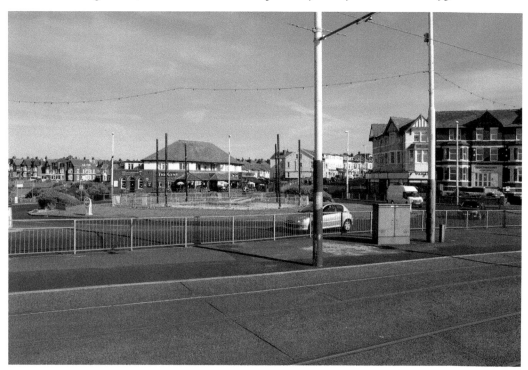

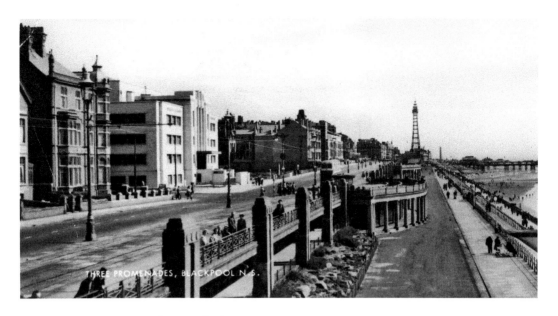

The Three Promenades, North Shore

The Claremont Park Estate from Cocker Street to the Gynn had been created in 1863 by the Blackpool Land, Building & Hotel Company and sea defence works were started in 1876 to protect Queen's Drive, the Imperial Hotel (1886/87) and other properties. The North Shore Works, between Cocker Square and the Gynn, and the three promenades were constructed in the period 1895–99. The colonnades and promenade widening works were completed in 1925. They allowed the tram tracks to be moved from the road to a separate reservation and also provided a long, covered walkway with seating facing the sea. Middle Walk was for many years the location for events such as the finish of the 'Milk Race' and vintage bus and car rallies.

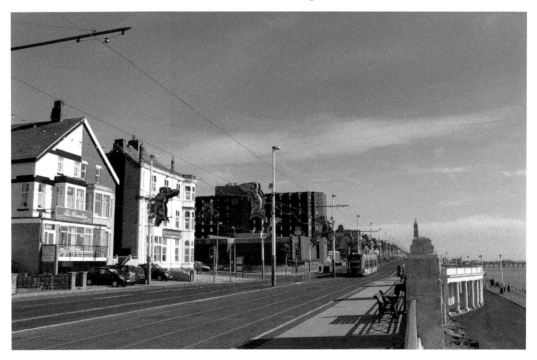

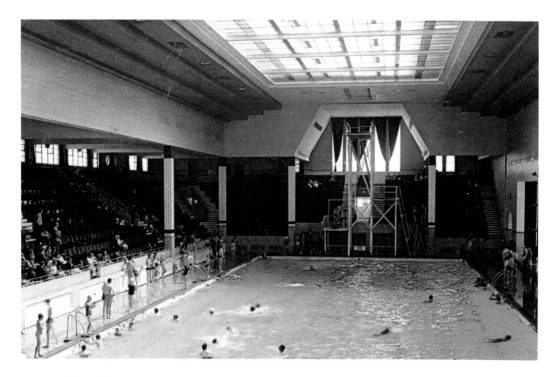

Derby Baths

Derby Baths and its Olympic-sized pool opened in July 1939 on Warley Road at the Promenade and regularly hosted international televised swimming events and diving competitions in the 1950s and '60s. There was a learner pool in the basement and a sun terrace on the south-facing part of the roof. A visit to the café at the north-east end of the baths was always a must after swimming, to have an oxtail soup, Bovril or hot chocolate. Despite the addition of the separate sauna in 1965 and later the Splashland tubular water slides, by the mid-1980s it was failing to compete with attractions such as the Sandcastle Water Park. The baths closed in 1988 and were demolished in 1990 due to the severe decay of the steel-framed structure.

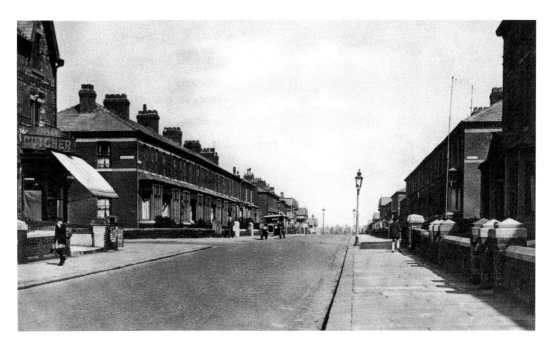

Warley Road

The houses of Warley Road, immediately to the left and right of this view, were built in the 1880s, before Ormond Avenue and Boothroyden were laid out. The shop to the right was Riley's butcher's shop for many years and has been converted back to a house. Further down Warley Road on the right is Clarement Park. One of Blackpool Tower's most famous clowns, Charlie Cairoli, lived with his wife Violetta at No. 129 Warley Road.

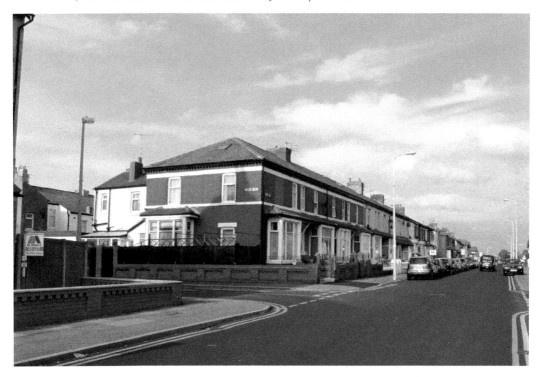

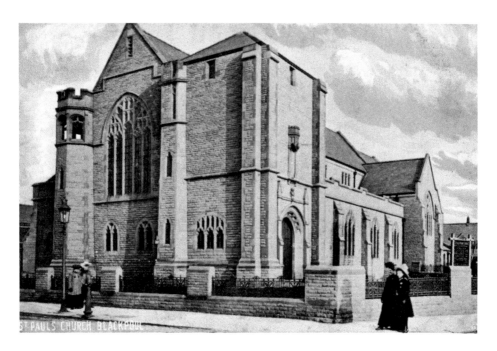

St Paul's Church

St Paul's Church on the corner of Dickson Road and Carshalton Road was opened in 1895 as a 'tin church'. The stone church in the Gothic style of architecture was designed by Messrs Garlick & Sykes and built at a cost of £8,500. It was consecrated by the Bishop of Manchester on 18 July 1899. A clock was installed in the west face of the tower in 1961. After the church closed the church building was sympathetically modified in 1995 to become St Paul's Medical Centre. Services are now held at the St Paul's Worship Centre in the adjoining building on Egerton Road, also the home of the 37th Blackpool Scouts.

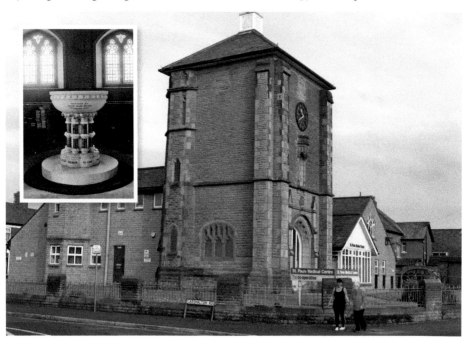

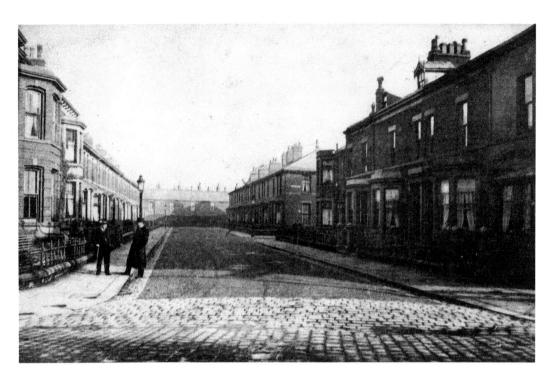

Bute Avenue

Bute Avenue is a residential street off Dickson Road, between the Claremont Hotel and the Imperial Hotel, and appears to have formed part of Upper Braithwaite Street (now Braithwaite Street – to the right in the photographs) from the 1870s to 1890s, before Bute Avenue was extended eastwards a little.

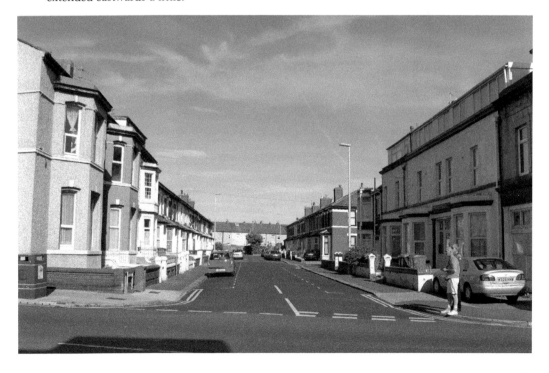

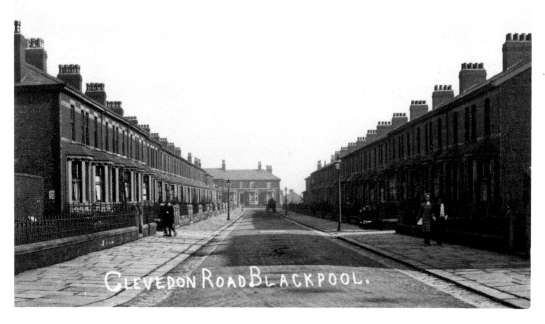

CLEVEDON ROAD BLACKPOOL.

Clevedon Road

Clevedon Road, along with the other four roads between Egerton Road and Sherbourne Road (all beginning with the letter 'C' except for Ashburton Road), was built in the late 1890s and early 1900s as the town rapidly developed northwards and inland. In the distance and to the right is the top of Clarement Road. Behind Clevedon Road there are a number of small businesses. Among them in the 1950s and '60s were a chicken factory and a rock factory that made Blackpool rock and Welsh humbugs. The rock factory is still there today.

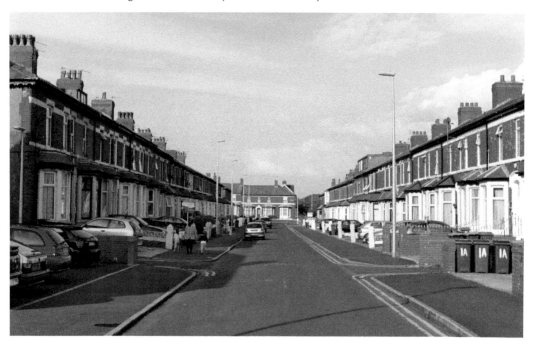

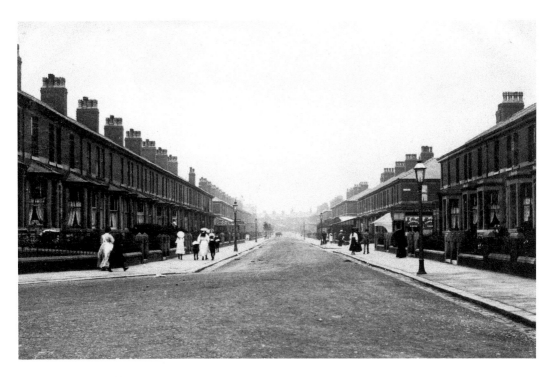

Egerton Road

Egerton Road looking north from Egerton Square about 1910. Cooper's grocer's shop is on the corner of Eaves Street to the left and E. Okell's bakery is on the corner of Clifford Road to the right. Egerton Road's largely unknown claim to fame is that Sgt-Maj. Edwin Hughes, the last survivor of the Charge of the Light Brigade, lived at Nos 42 and 64 Egerton Road in the latter years of his retirement. He died on 18 May 1927 aged ninety-seven.

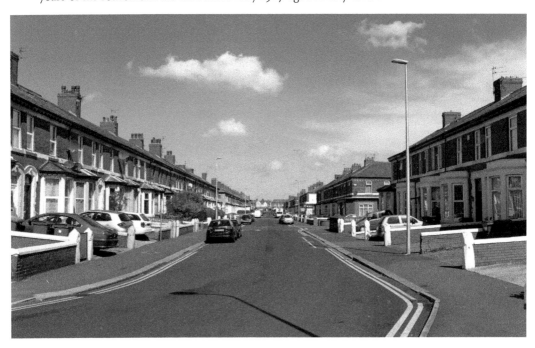

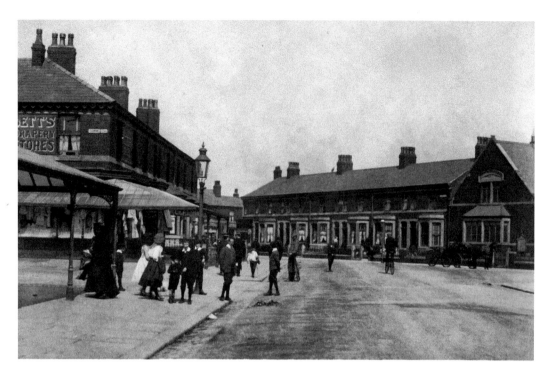

Egerton Square

This small but busy shopping area of North Shore, seen above in the early 1900s, is known locally as Egerton Square. The draper's shop to the left on the corner of Richmond Road is now a leisure facility, and the Ebenezer Methodist Church to the right was demolished in 1982 and is now a housing development named Richmond Court.

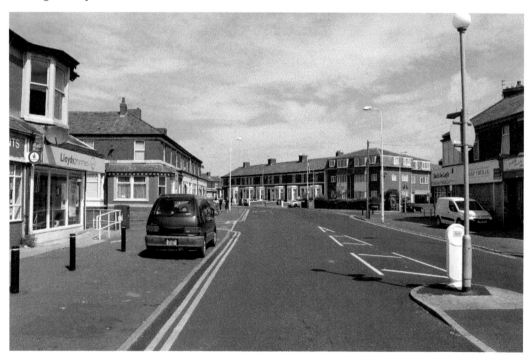

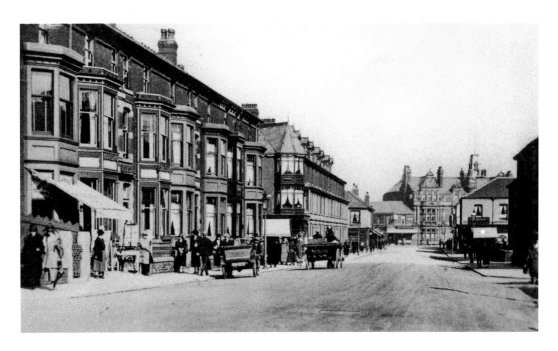

Pleasant Street

A busy and thriving Pleasant Street is seen here in the 1920s with shops on most corners and the houses mainly developed into boarding houses. Cliff House, built in the mid-1800s, previously stood on its own to the right with gardens between Braithwaite Street and Lynn Grove. Part of the house still remains on the east corner of Lynn Grove. The Empress Hotel on Exchange Street is in the distance; it charged 6s 6d for 'bed & breakfast' in 1935. Lord Street and High Street are off to the right.

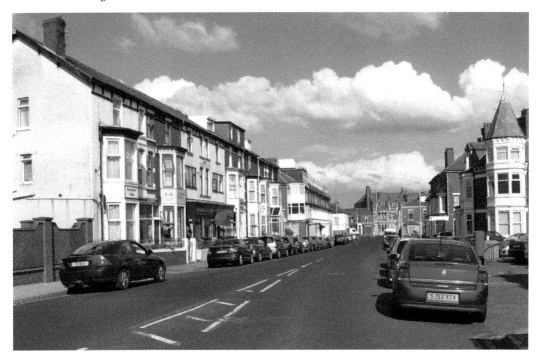

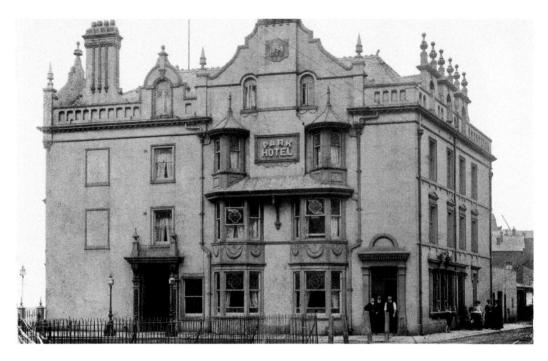

Park Hotel

The Claremont Hotel was rebuilt as the Park Hotel in 1894 and has been called the Carlton Hotel since the 1920s. The next hotel to the south is the new Claremont Hotel, which was opened in 1894. The Park Hotel is seen above around 1905, and below is the Carlton Hotel as it is today, with the sun lounge that was added in the 1930s.

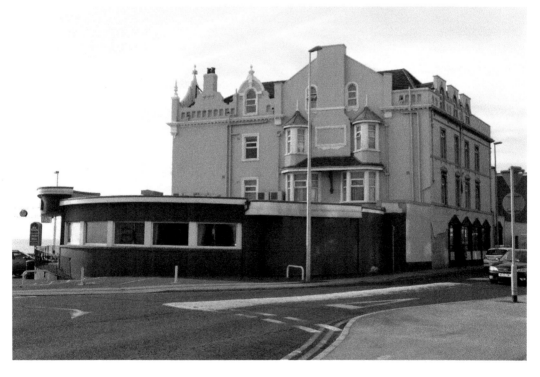

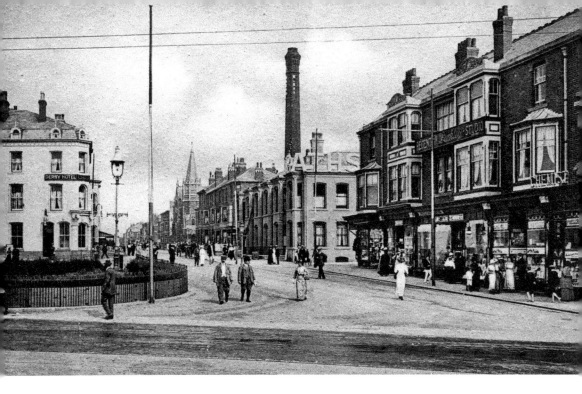

Cocker Square

To the left of this view of Cocker Square, on and around the fenced area which is now a car park, was the old eighteenth-century community of Fumblers Hill, the last cottage being demolished in the late 1890s. In the centre is Cocker Street Baths. These seawater baths were built in 1870 and reopened in July 1873 by Jonathan Read. The Corporation purchased the baths in April 1909 and this spartan facility was demolished in 1974. To the left is the Derby Hotel, now Liberty's Hotel in Cocker Square.

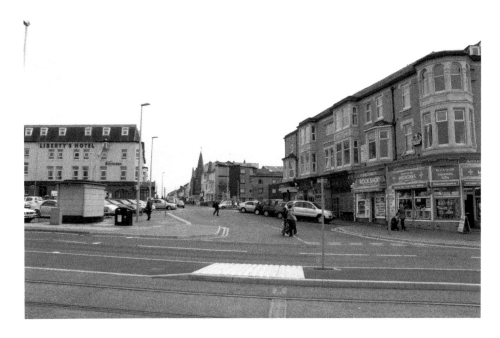

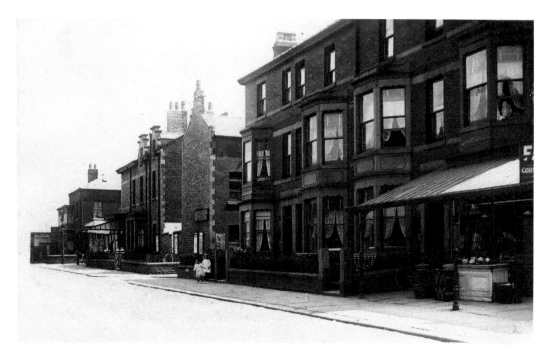

Springfield Road

Springfield Road, like other streets in this area, comprised mainly boarding houses catering for holidaymakers. The closure and demolition of North Station on Dickson Road in 1974 and the station's relocation to High Street, combined with Springfield Road becoming part of the incomplete inner ring road in the late 1970s, led to some of the properties being demolished and the road becoming very busy. The inset view shows a typical group of holidaymakers in the late 1950s, posing outside of their Springfield Road boarding house.

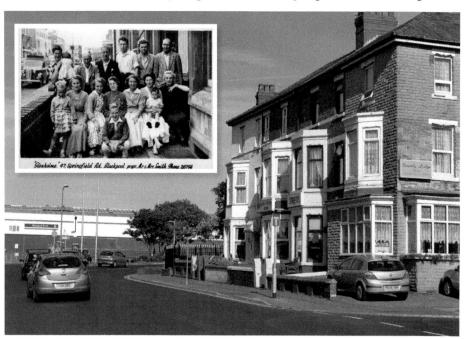

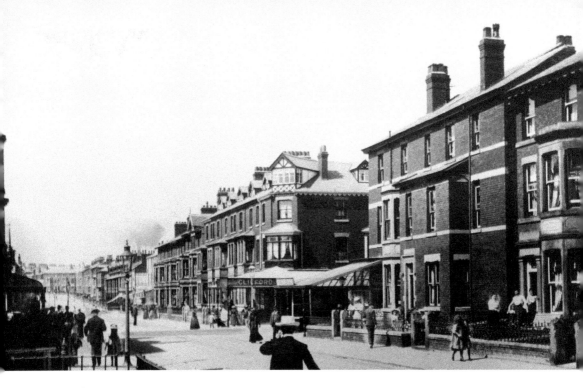

Lord Street

The guesthouses in Lord Street and the surrounding area benefited significantly from their proximity to North Station and its excursion platforms exiting onto Upper Queen Street and Springfield Road. Seen here around 1905 looking north across Springfield Road from just behind what is now Funny Girls (formerly the art deco Odeon Cinema), Lord Street has changed little except for extensions to the front of some properties and the invasion of the motor car.

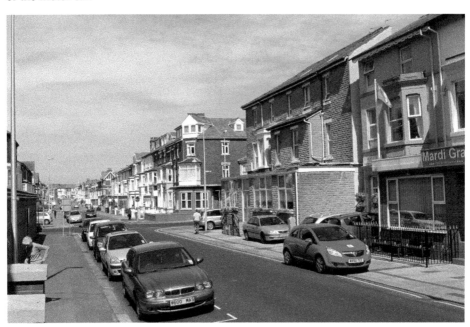

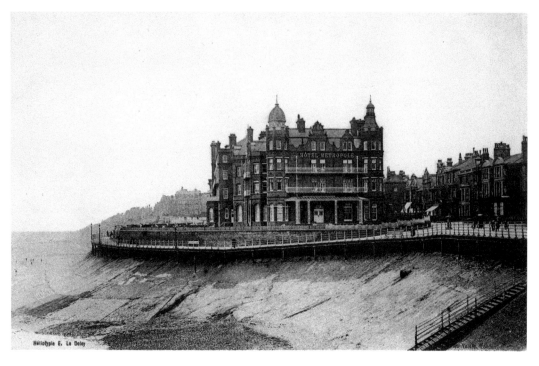

Metropole Hotel

The Butlin's Metropole Hotel was originally Bailey's Hotel and is one of Blackpool's oldest hotels. The hotel was renamed Dickson's in the 1840s and is seen here in the early 1900s, looking north from North Pier before Princess Parade was constructed.

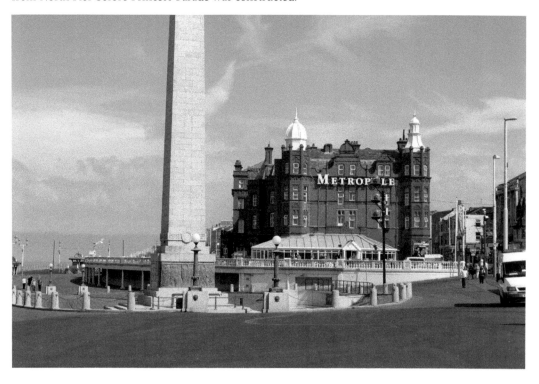

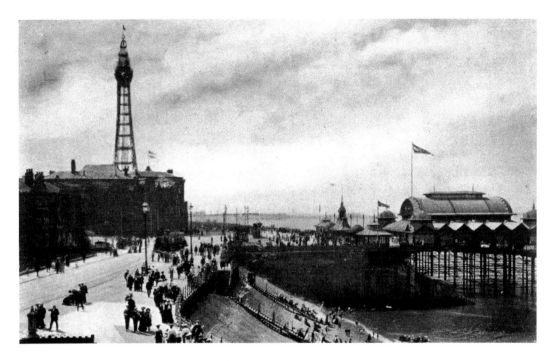

Looking South from the Metropole Hotel

This postcard view taken from the Metropole Hotel shows the northern end of the promenade widening works between North Pier and South Shore that were completed in July 1905. The further extension of the promenade works to Princess Parade from North Pier to Cocker Square took place between October 1910 and September 1911 and used basalt blocks from the Giant's Causeway. Princess Parade was opened by HRH Princess Louise on 1 May 1912 and this area of the Promenade was 'illuminated' with a static display. Albert Terrace and Talbot Square are to the left.

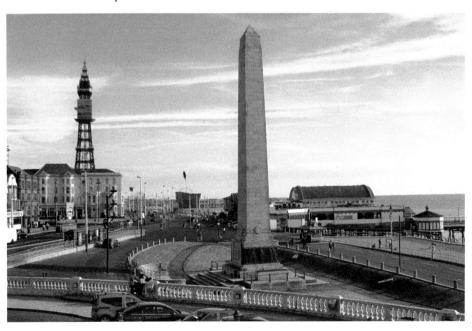

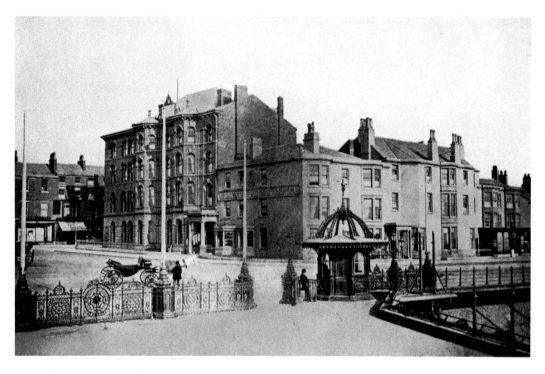

The Clifton Arms Hotel in the 1870s
Originally this view would have been a view of Forshaw's Hotel, one of Blackpool's first lodging places, built around 1780 on the corner of what is now Talbot Square and the Promenade. Forshaw's was sold to Thomas Clifton in 1832 and was reconstructed and replaced by the four-storey Grade II listed Clifton Hotel in the period 1865 to 1874. It is seen here from inside the cast-iron gates of North Pier in the 1870s, before the full reconstruction of the north-west corner of the hotel had been completed.

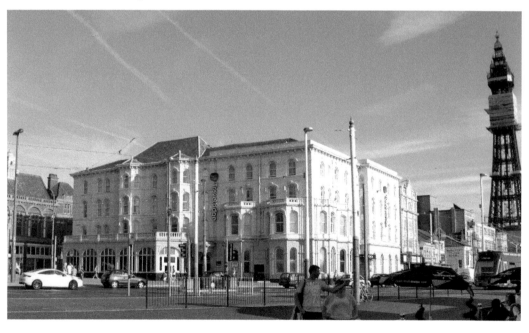

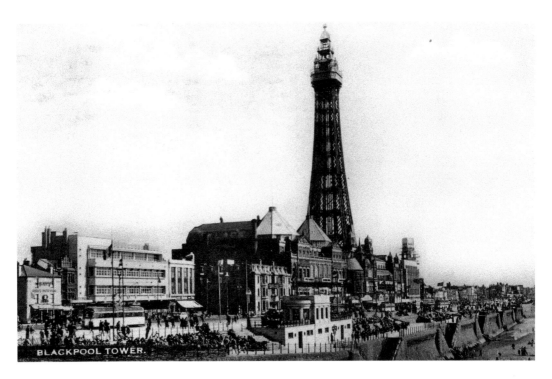

BLACKPOOL TOWER.

Tower and Promenade from North Pier

This 1940s postcard view of the Promenade taken from North Pier shows, from left to right: Robert's Oyster Rooms; the modern Savoy Café building opened in 1937; Burton's Buildings, where the Albion Hotel had previously been until 1925; the County & Lane Ends Hotel at the bottom of Church Street (now Harry Ramsden's); the Palace, which was Lewis's from 1962 until it closed in 1993; the Tower; Woolworth's with its clock tower, which was completed in 1938; and the tourist information centre and toilets on the west side of the tram tracks.

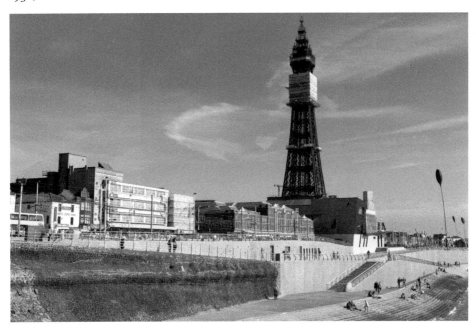

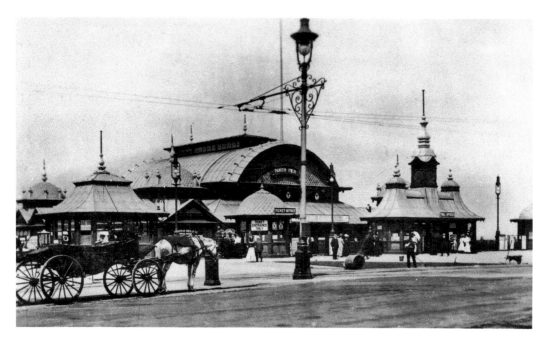

North Pier

North Pier, Blackpool's first pier, was built by the Blackpool Pier Company and opened on 21 May 1863. The originally constructed pier was a simple but elegant structure intended for 'promenading'. A jetty was added between 1864 and 1867, a new entrance was built in 1869 and the deck was widened in 1896. In 1903 an 'Indian' pavilion, shops and an arcade were added to the shoreward end. The pier is seen here in around 1905 when the ticket price was 2*d*. The Merrie England bar was opened in the 1960s and the pier was given a Victorian-style entrance in the 1980s. The pier is now owned by a Blackpool family firm, the Sedgwicks.

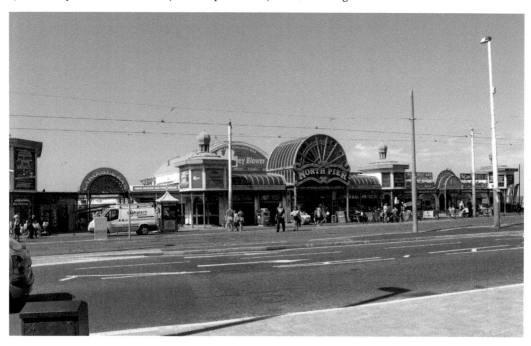

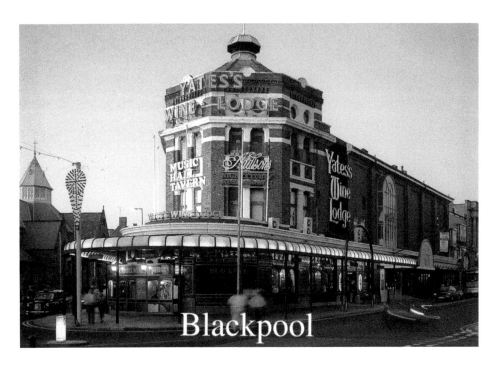

Blackpool

Yates's Wine Lodge

Opened in 1868 as the Theatre Royal & Assembly Rooms, the octagon rooms became the town's first free library in 1880. The site was bought by Peter Yates (a wine merchant) in 1894/96 and opened as Yates's Wine Lodge in July 1896. It is seen above in recent years, although since the fire in February 2009 the site of this landmark building has not yet been redeveloped. To the left of the picture is the Church of the Sacred Heart of 1857, Blackpool's first Catholic church, designed by Pugin.

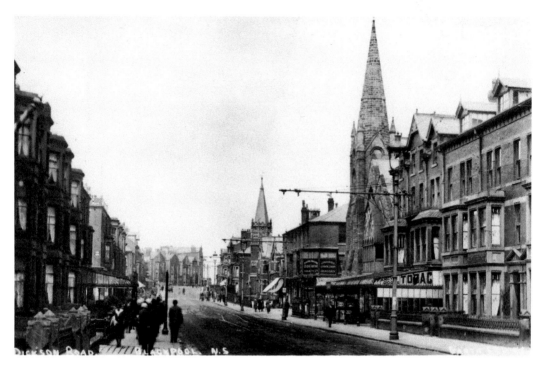

Dickson Road

This view of a traffic and tram free Dickson Road looking north from near Springfield Road dates from around 1910. The terminus of the Blackpool & Fleetwood Electric Tramway Company was just behind this view and the passing loop of the single line tram track going north to Fleetwood via the Gynn can be seen in the road. To the right is Banks Street Unitarian Church which was founded in 1873 and closed as a church in 1975. Further along on the right is Dickson Road's Grade II listed Wesleyan Methodist Church, built in 1899.

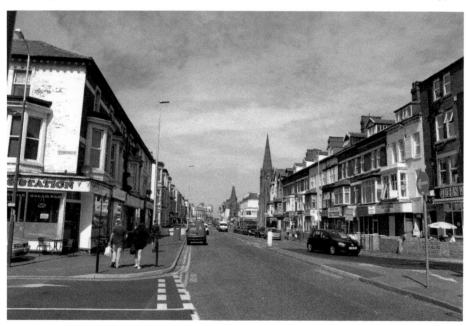

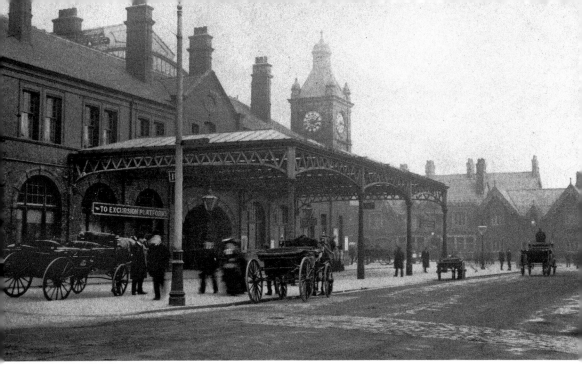

North Station, Dickson Road

When the railway link from Poulton to Blackpool opened on 29 August 1846 the station was named Talbot Road Station. The original station building was replaced in 1897 by the red-brick building seen here fronting Dickson Road, with glass canopy over the entrance and clock tower. The station and tracks between Dickson Road and High Street were demolished and removed in 1974 and a bland, concrete panelled Fine Fare supermarket with a car park took its place. The site has been occupied by a Wilkinson store for many years now. To the right of the picture are the Talbot Hotel, built in 1845, and the houses of Talbot Terrace on the new road to Layton.

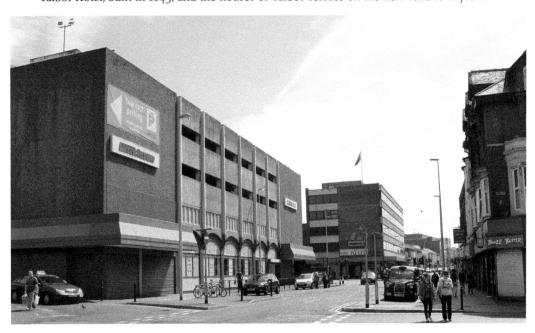

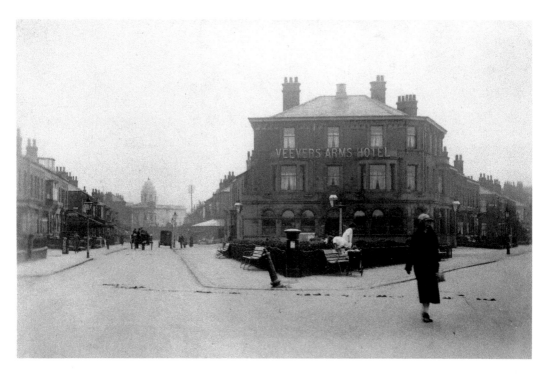

Veevers Arms Hotel

The Veevers Arms Hotel on Cookson Street at its junction with King Street was bought by Threlfall's Brewery in 1900 and was named after Richard Veevers, a land agent of Preston, who died in 1902. It is now known simply as The Hop. In the distance at the bottom of Cookson Street is the faience-tiled Regent Picture House, which opened in January 1921 and was converted to a bingo hall in the late 1960s. It is now a Rileys snooker hall.

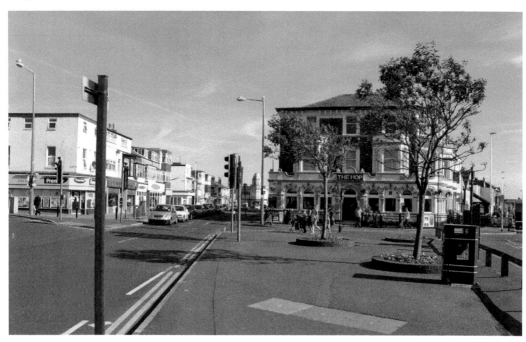

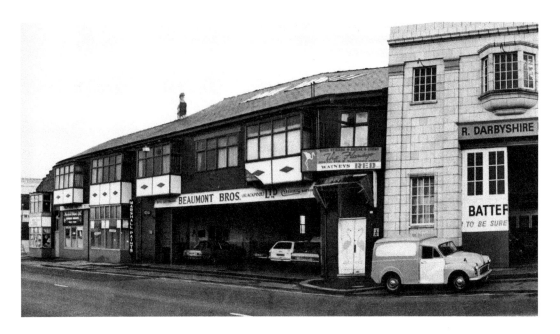

Talbot Road and the Flamingo Club

This stretch of Talbot Road, from Swainson Street to Lark Hill Street, was from 1979 the home of the Flamingo Club, Blackpool's first gay nightclub, seen in the centre of the picture above the garages. The buildings were demolished around 2007 to make way for the Talbot Gateway development. This was followed by the demolition of the property east of Cookson Street and Talbot Road in 2012. To the left, on the east corner of Lark Hill Street, is the Theakston's real ale Wheatsheaf pub, which closed in 2004 and has since been demolished.

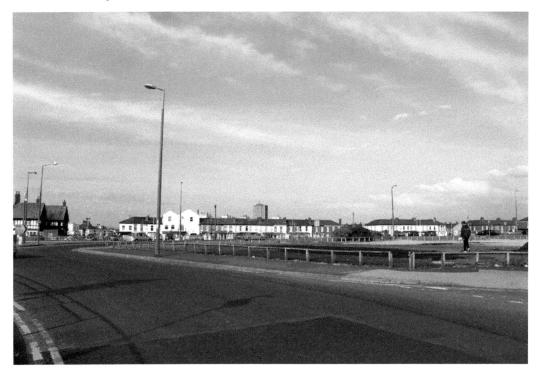

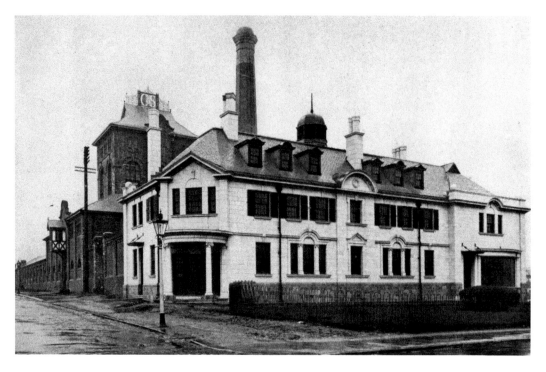

C&S Brewery, Talbot Road

The brewery was built by Catterall & Swarbrick Brewery Limited in 1927 on the corner of Talbot Road and Abattoir Road. C&S was best known for its XL Ales but the brewery brochure also stated that C&S blended its own Scotch whisky. C&S were taken over by Bass Charrington in the 1960s and brewing stopped in 1974. The brewery was demolished in 2000 and the site has been redeveloped for housing with road names such as Coopers Way, Catterall Close and Swarbrick Close.

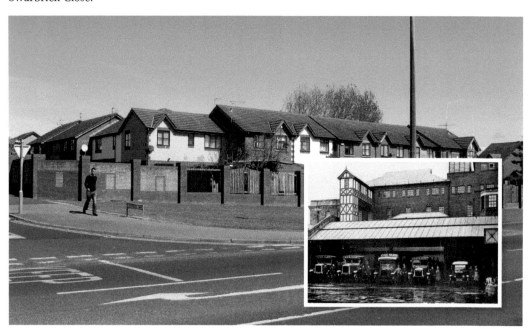

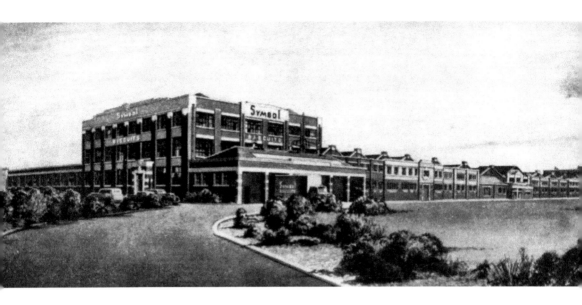

Symbol Biscuits

Symbol Biscuits, as we all know it, originated in 1922 as the Blackpool Biscuit Company and later Bee Bee Biscuits. Building of the new factory at the Mansfield Road site commenced in 1932 and the company was one of the pioneers of pre-packed biscuits instead of loose biscuits in tins. Probably the best-known biscuit produced there was the Maryland Cookie (from 1956). If a family member worked at Symbol it would be a treat when they came home with bags of broken biscuits. It is now owned by Burton's Biscuit Company.

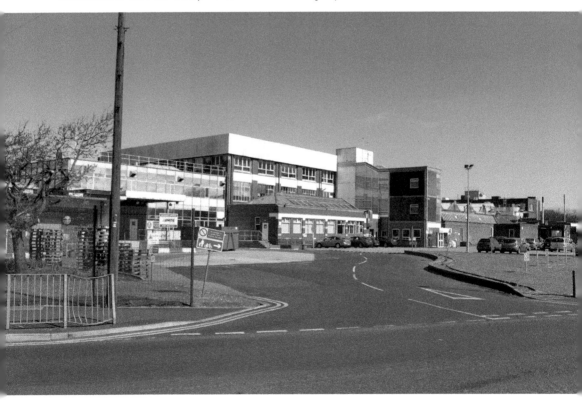

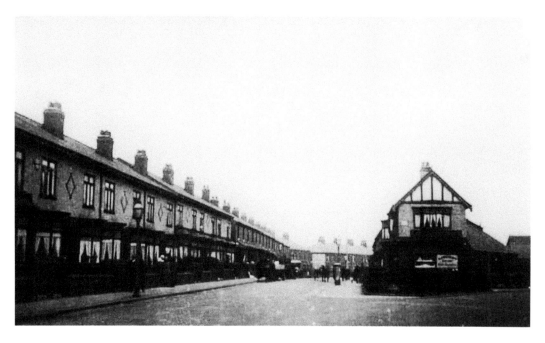

Onslow Road

Onslow Road has not changed a great deal over the years and is seen here at its junction with Lyncroft Crescent looking east from near Westcliffe Drive. Lyncroft Crescent was the original route leading to Little Layton and Grange Farm. The house in the centre was Little Layton post office until it was moved to the shop on the north corner of Onslow Road and Westcliffe Drive. To the right at 1–3 Lyncroft Crescent is the RAOB Club, opened in 1911.

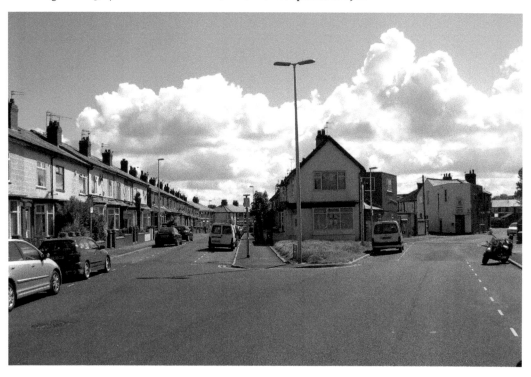

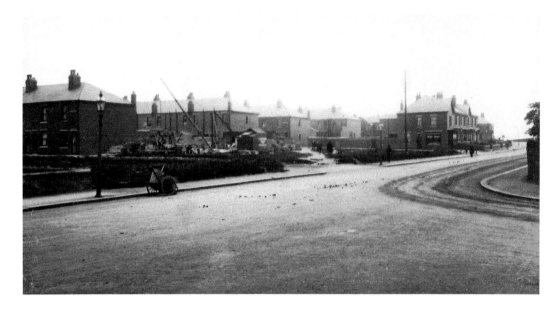

Layton Lane (Layton Road)

As the town of Blackpool grew and outstripped the surrounding villages and hamlets, including those of Bispham and Layton, the residential and commercial development of greenfield sites such as this area between Hoo Hill and Layton (then at the No. 4 end of Layton Road) took place. In this early 1900s photograph the houses of Broughton Avenue and Drummond Avenue are largely in place with the shop properties fronting onto Layton Square still to be built. The tramroad from Talbot Square (the New Road) to Layton Cemetery, which opened in June 1901 and closed in 1938, terminated just in front of this view.

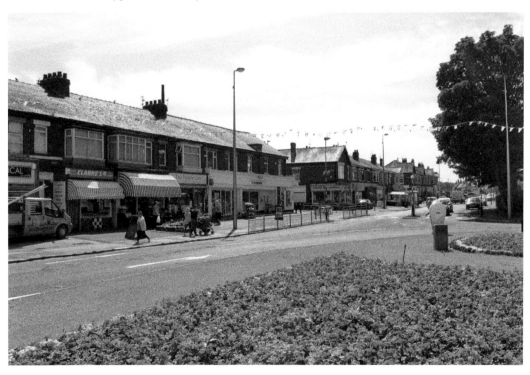

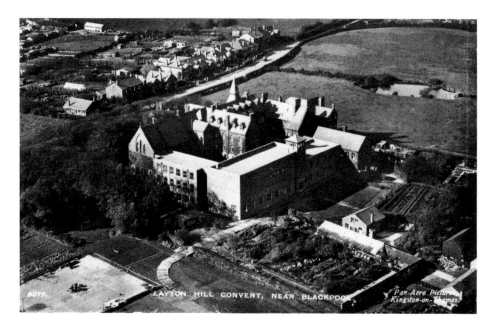

Layton Hill Convent

The first catholic girls' school in Blackpool began in the 1850s in Queen Square before it moved to Raikes Hall in 1860. In 1870 land was purchased at Layton Hill, which was then a remote part of the town. It was to become St Walburga's Road. The Convent of the Holy Child Jesus was usually known as Layton Hill Convent and was co-educational in the period between 1880 and 1900. It re-merged with St Joseph's College in 1975 to form St Mary's Catholic College. The college is undergoing further extension and remodelling, which will bring Christ the King Primary School to the site. Here it is seen from the air in the 1940s, before St Walburga's Road was made into a dual carriageway and the houses of Chepstow Road, Dingle Avenue and others on Grange Park were built.

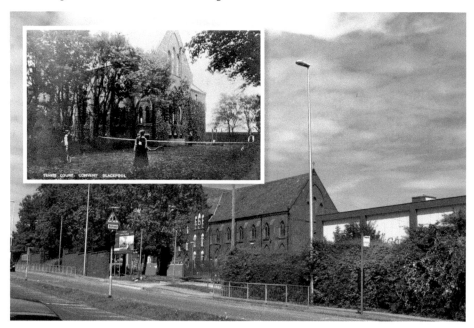

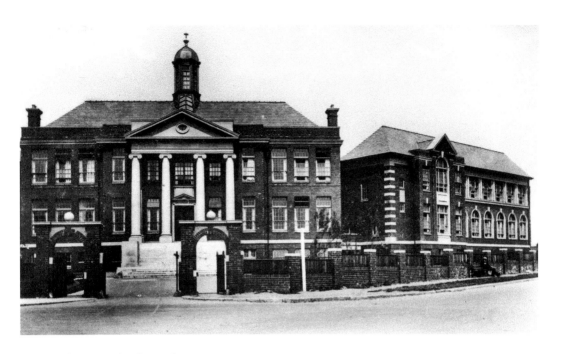

Collegiate School, Beech Avenue

The Blackpool Girls' Secondary School on the corner of Beech Avenue and North Park Drive began in 1925 and was officially opened on 23 October 1928 by Lady Stanley. The school changed its name in 1933 to the Blackpool Collegiate School for Girls and amalgamated with Blackpool Grammar School (a boys' school) to become the Blackpool Collegiate Grammar School in 1971 and moved to Blackpool Old Road. The school building became part of Tyldesley High School. It was demolished in 1987 and the Grizedale Court flats were built.

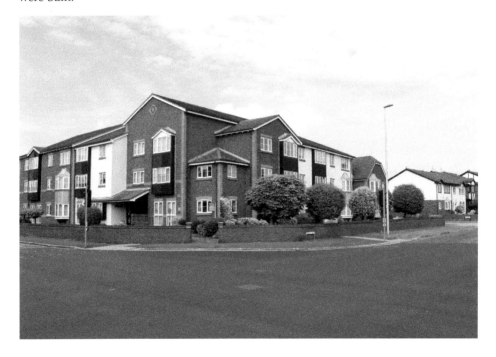

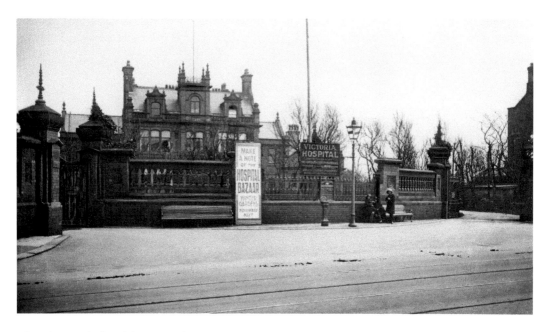

Victoria Hospital, Whitegate Drive

Blackpool Hospital was originally on Whitegate Drive (then Whitegate Lane) and opened 20 August 1894, then having twelve beds and three cots. It was maintained by voluntary subscription. The hospital was extended in 1897 and two new wards added; a further two 'iron' wards were added in 1898. Approval was given by Queen Victoria in 1897 to rename it Victoria Hospital. The new, state-of-the-art Whitegate Health Centre opened on 16 November 2009. The original gateposts and wall have been largely retained.

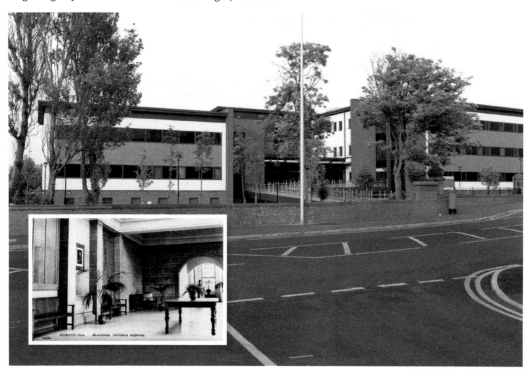

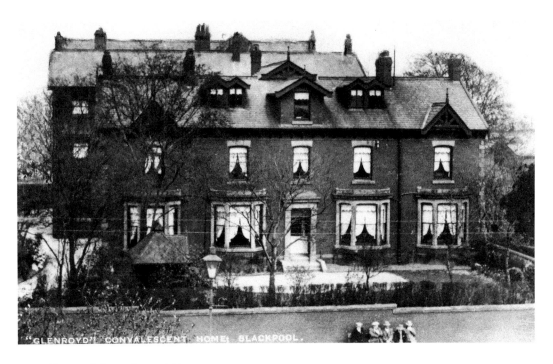

Glenroyd Convalescent Home

The North-Western Co-operative Convalescent Homes Association helped members of Co-operative families back to health. It had two homes: Glenroyd on Whitegate Drive in Blackpool and Thorpe Dene, Westwood, Scarborough. Glenroyd was opened on 14 April 1906 and was open to visitors as well as convalescents. There was a billiard room, lawned garden, glasshouse, and an orchard to the rear. Bedrooms were mostly for two persons and baths could be taken as often as desired without extra charge. The home was requisitioned in 1946 for maternity cases. It was closed in 1975 after the new maternity wing at Victoria Hospital opened, and was demolished the following year. The site is now Glenroyd Medical Centre and Glenroyd Care Home.

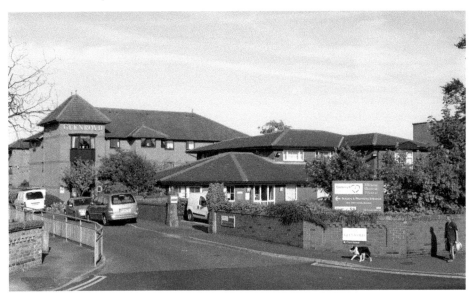

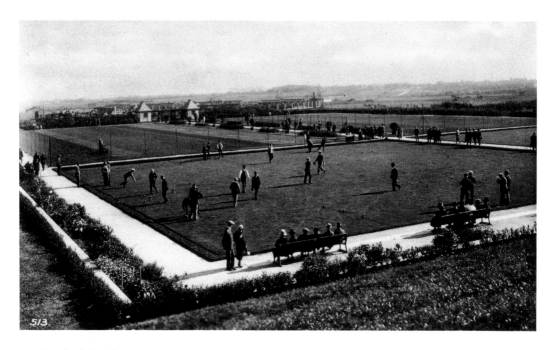

Stanley Park Bowling Greens

Stanley Park was opened on 2 October 1926 by the Earl of Derby, KG, in some 232 acres of land with a 26-acre boating lake; three bowling greens; thirty-eight tennis courts (twenty-four hard and fourteen grass); an athletic ground with cinder track; twelve putting courses (eighteen-hole); one eighteen-hole golf course; three cricket pitches; four football grounds; a green for hockey playing; children's yacht pond and paddling pool; conservatories; botanical, rose and Italian gardens; and a bandstand with seating accommodation for about 3,000. In the summer 2012 photograph below, Stanley Park Ladies (in pink) are playing against Warrenhurst Park Ladies (in blue) of Fleetwood.

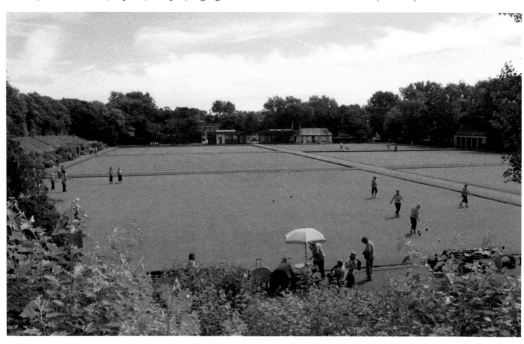

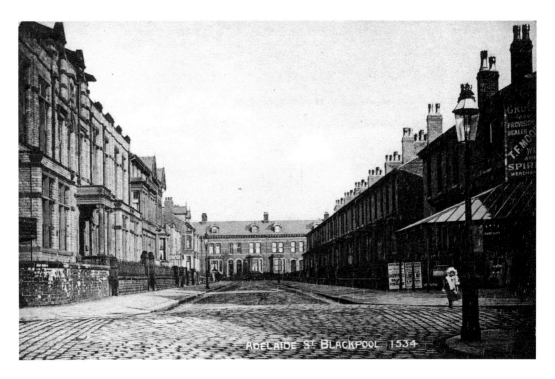

Adelaide Street

A deserted and cobbled (Upper) Adelaide Street is seen here in the early 1900s. To the left is the Blackpool Masonic Lodge, which was opened on 23 September 1899, having moved from the Clifton Arms Hotel. The foundation stone of the Lodge was laid by Lord Skelmersdale on 7 May 1898. Adelaide Street housed most of Blackpool's leading solicitors for a time, including John Budd & Co. To the right, the grocer's shop is now a Co-operative pharmacy. Regent Road is at the top of the street.

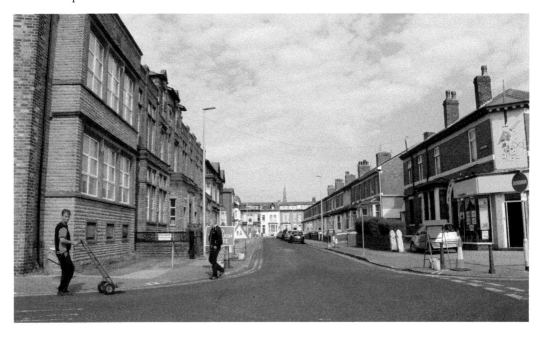

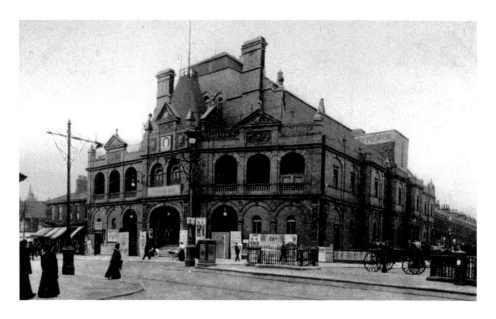

The Hippodrome, Church Street

One of Blackpool's most changing entertainment venues, the Empire Theatre on the corner of Church Street and King Street opened as a ballroom/music hall on 4 July 1895, becoming the Hippodrome Theatre in 1900, when it housed a circus. It later became a cinema and variety theatre before being bought by Associated British Cinemas in 1929. It closed in 1960 and was remodelled and renamed the ABC Theatre, which opened on 31 May 1963 with Cliff Richard & The Shadows starring in Holiday Carnival. The Beatles played there in 1963 and 1965 for ABC Weekend Television's *Blackpool Night Out*. In 1981 the theatre closed and was converted into a three screen cinema. It was renamed the Cannon Cinema in 1986 and the MGM Cinema in May 1993. The cinema closed in 1998 and opened as the Syndicate Superclub in December 2002.

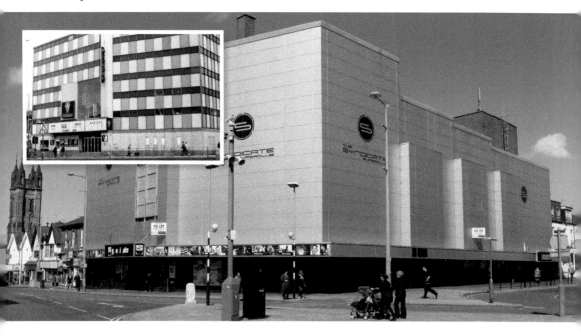

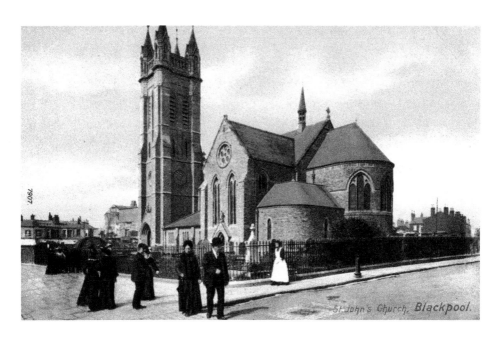

St John's Church, Church Street

Blackpool's first church was the Church of St John the Evangelist near the corner of Abingdon Street and Church Street and was consecrated on 6 July 1821 and demolished in 1877. The present Gothic church was consecrated on 25 June 1878 and has recently been redeveloped and new spaces created for both church and community use. The area of Church Street around the church has now been transformed from a busy through route to a well-designed pedestrian piazza and is known as St John's Square. The focal point of the square is the 10½-metre-high steel sculpture with diving figure and illuminated resin inserts named *The Wave* and installed in September 2009 just before the square officially opened.

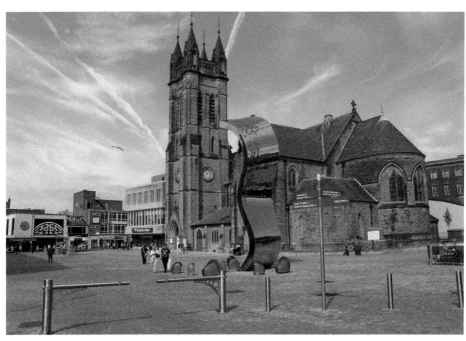

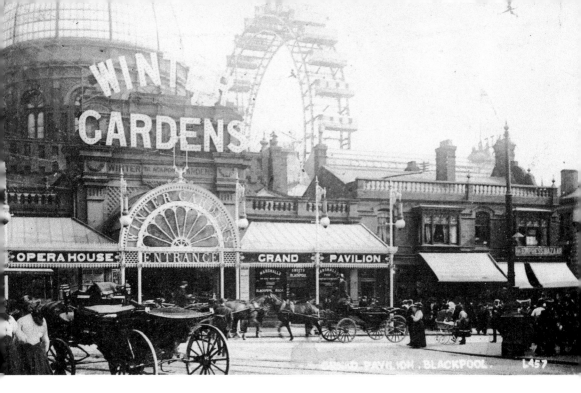

The Winter Gardens, Church Street

The Winter Gardens was built on the Bank Hey Estate of Dr Cocker, the first Mayor of Blackpool. An open-air skating rink was opened in July 1876. Two years later the main entrance vestibule, with a 120-foot-high glazed dome, and the new pavilion, containing the concert hall and floral hall, also opened. The Empress Ballroom with its decorated balcony on three sides and the Indian Lounge both date from 1896. The Winter Gardens has hosted the annual conferences for all of the main British political parties and has been the home of the Blackpool Dance Festival since 1920. The Winter Gardens were purchased by Blackpool Council from Leisure Parcs Ltd in 2010.

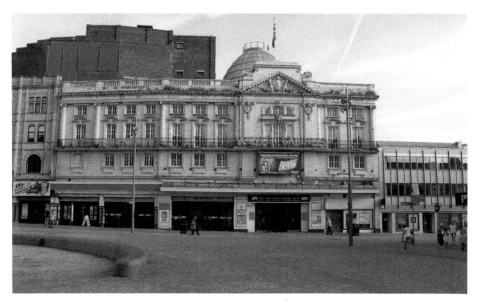

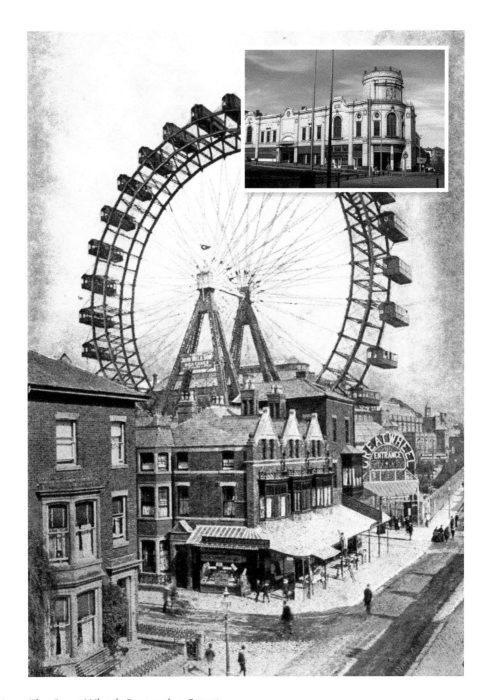

The Great Wheel, Coronation Street

The entrance to the Great Wheel, which was 200 feet in diameter, was on the corner of Coronation Street and Adelaide Street, now the site of the Olympia. The Great Wheel opened on 22 August 1896 and had thirty carriages, each capable of holding thirty passengers. Purchased by the Winter Gardens Company in 1916 for £1,150.00 it closed on 20 October 1928 and its carriages were sold off at auction for £13 each. Tower Street is to the left of the view from around 1910 but the block of properties between Tower Street and Coronation Street were demolished in late 2010.

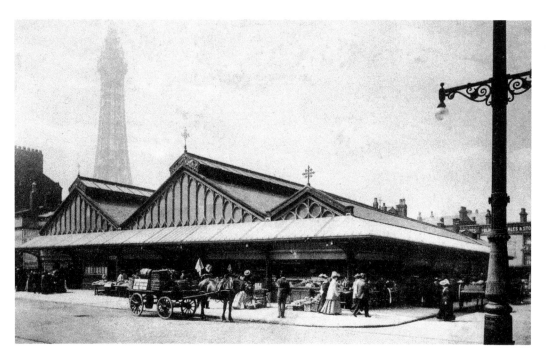

St John's Market, from Corporation Street

The original St John's Market opened in 1844 and was located on Market Street until 1893 on the site of what is now the Municipal Buildings. The market seen here on the corner of Corporation Street and West Street was the later St John's Market extension which was demolished in 1939 and is now British Home Stores and West Street multi-storey car park.

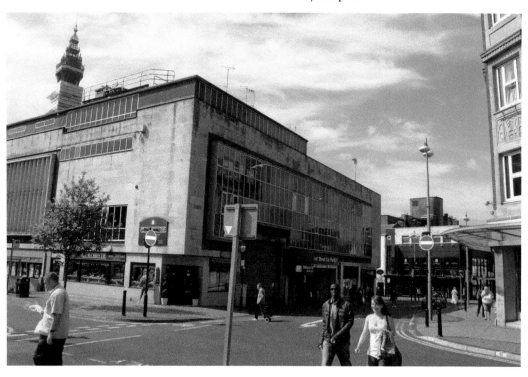

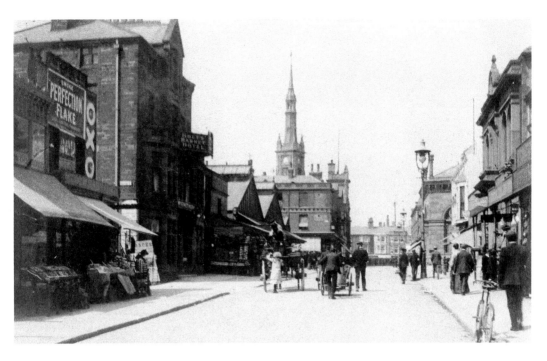

Corporation Street

Corporation Street was originally named Lytham Street and is seen here from near Church Street around 1905. To the left is Euston Street. The block of property, bounded by Church Street, Market Street, Corporation Street and West Street, which included Euston Street, was demolished to make way for the British Home Stores that opened in May 1957. Just beyond Euston Street is the Market Hotel and further up is the St John's Market extension. In the distance is the town hall, opened in 1900, with its spire, which was demolished in 1966. Birley Street is on right.

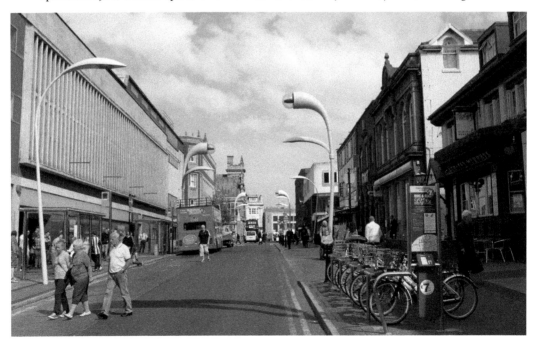

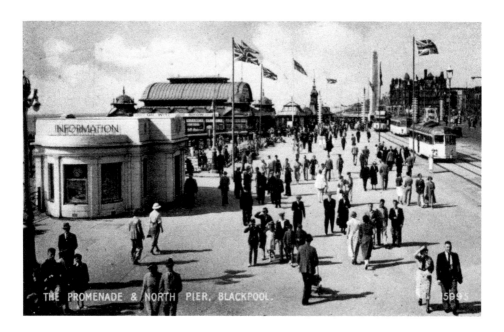

Promenade Looking North to North Pier and Talbot Square

The Tourist Information Centre, seen here to the left in the late 1940s, was one of only a few buildings on the west side of the tram tracks until recent years. A new, twelve-sided Tourist Information Centre was built in 1989 before the centre was moved to Clifton Street. In the distance is North Pier, the Metropole Hotel and the cenotaph war memorial which was erected on Princess Parade and unveiled on 10 November 1923. The view is now dominated by the gold, stainless steel, shingle-clad Festival House, which opened in December 2011 on the new Festival Headland and now houses Blackpool's Register Office and the Tourist Information Centre.

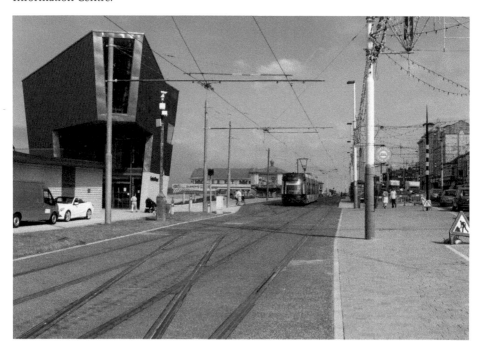

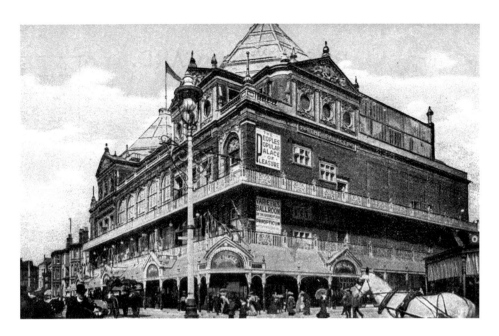

The Palace

This site was originally a row of houses named Hygiene Terrace. It was replaced by the Prince of Wales Theatre (1879) and Baths (1881), which themselves were replaced by the Alhambra in May 1899. The Alhambra had a magnificent entrance hall and a 'conservatory' on the top floor, together with a circus, theatre and ballroom. The Alhambra was not a financial success. The Blackpool Tower Company took charge in 1904 and it reopened as the Palace Theatre. In 1935 the cost of the Variety & Revue show ranged from 1s to 2s 6d. Lewis' department store with its distinctive 'honeycomb' front façade occupied the site from 1962 to 1993, and the site is now occupied by a variety of shops.

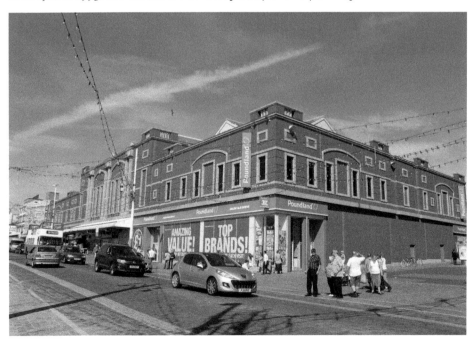

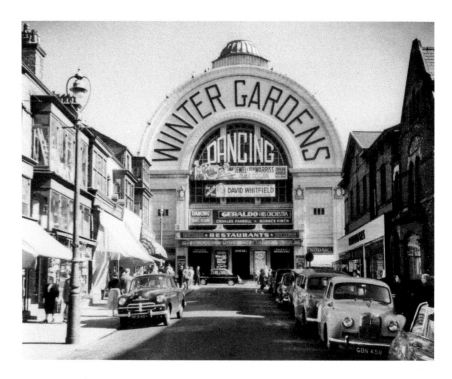

Winter Gardens, Coronation Street Entrance

The Bank Hey, home of Dr W. H. Cocker, Blackpool's first mayor, was originally on the land behind the façade of the Coronation Street entrance of the Winter Gardens, built in 1896 to attract visitors away from the Promenade, which even today is not an easy task. The imposing white faience cladding was added in the 1930s when the Olympia was built. In the modern view of Victoria Street, commercial development has sadly taken precedence over the simplistic elegance of what is in effect a large advertisement.

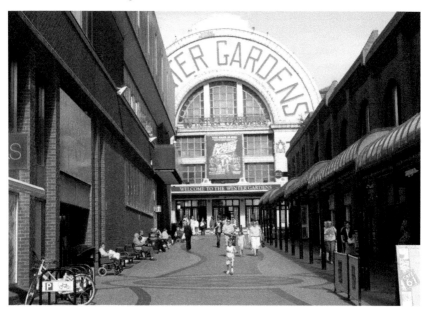

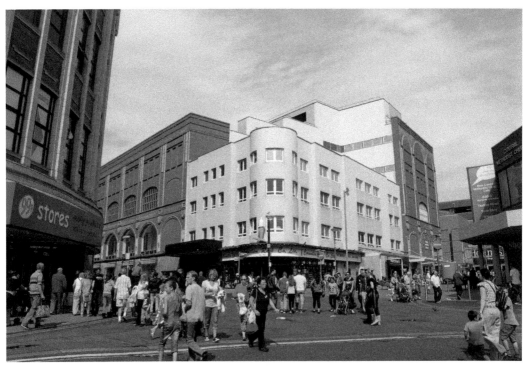

Lockhart's Café, Bank Hey Street
A 1930s view of Lockhart's Café at
58 Bank Hey Street on the corner of
Adelaide Street, before it was rebuilt
with four storeys in the modernist
style with cream tiles as it is today.
The building is now the home of
the Coronation Rock Company,
Waterstones book shop and Primark.

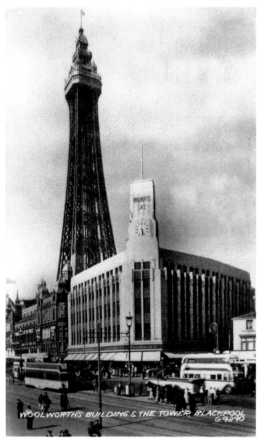

WOOLWORTHS BUILDING & THE TOWER BLACKPOOL
G.9290

Woolworth's and the Tower

Woolworth's opened in 1937 on the site of the eighteenth-century Royal Hotel and a small Woolworth's store. The first and second floor housed a 2,000 seat café and in 1939 roast beef and Yorkshire pudding was 6d with vegetables 3d extra each. From 1985 to 2008, Pricebusters Market operated the building which is now 99p Stores and a Wetherspoon's public house. The Tower opened on 14 May 1894 and while the zoo and aquarium have gone, Blackpool's most famous attraction still includes a circus and the famous Ballroom, not forgetting the lifts to top of the Tower. The Tower has recently completed a multi-million-pound re-vamp and includes the Blackpool Tower Dungeon, 3D cinema and 'walk of faith' glass floor at the 380-foot viewing platform.

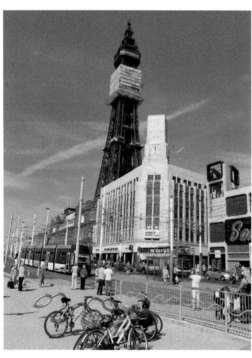

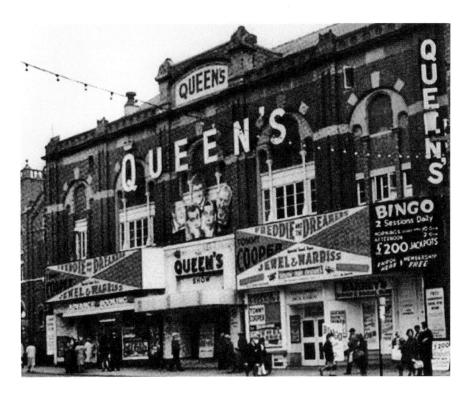

Queen's Theatre

Like many parts of Blackpool, this area of Hounds Hill has undergone several changes. The Queen's Theatre is seen above in 1965 when the great Tommy Cooper (1921–1984) was joint top of the Bill, with Freddie and the Dreamers. The Borough Theatre & Bazaar (Bannister's Bazaar) opened here in 1877. It became Feldman's Theatre in 1928 and the Queen's Theatre in 1952. The Queen's was demolished in 1973 and became C&A, and is now a mixture of shops, including TK Maxx, Betfred, Savers and Bonmarché.

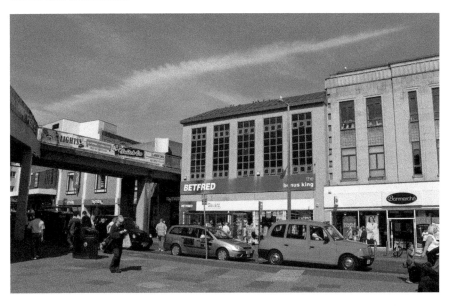

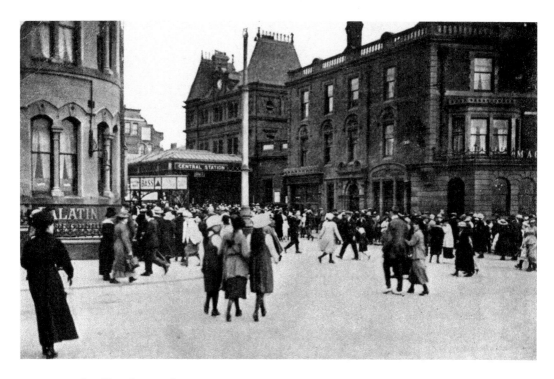

Hounds Hill and Central Station

From a time long before the town of Blackpool began, this was known as 'the Houndehill in Laton' and gave its name to the road from the Promenade to the end of Bank Hey Street. Central Station opened in 1863 after the Blackpool & Lytham Railway was extended but even though it was Blackpool's busiest railway station it closed in 1964, largely due to the development potential of the station land near to the Tower and Promenade and the railway sidings to the south. The New Inn & Central Hotel building is to the right. The site of the station and New Inn was redeveloped in the late 1970s as the Coral Island complex.

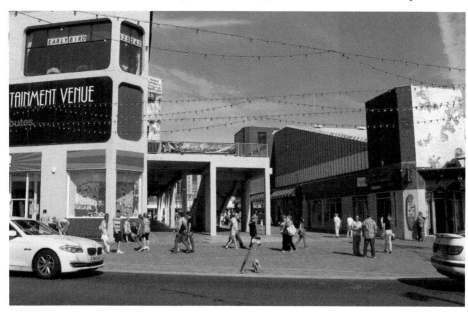

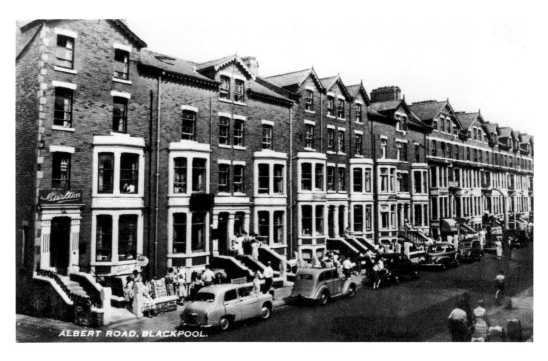

Albert Road

The hotel and guesthouse properties of Albert Road have changed little, except than many have acquired front 'lounge' extensions and some have been extended upwards with 'roof lifts'. The cars in the 1940s photograph would all now be classics, and it shows the two-way road before traffic management was invented.

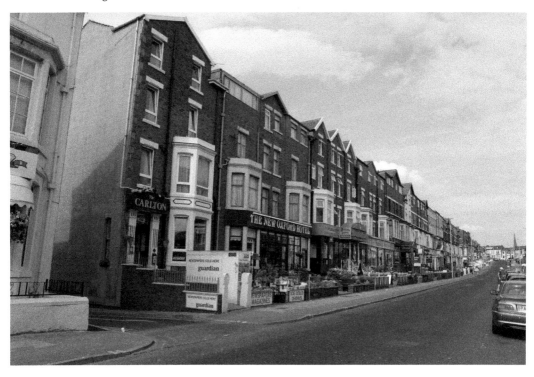

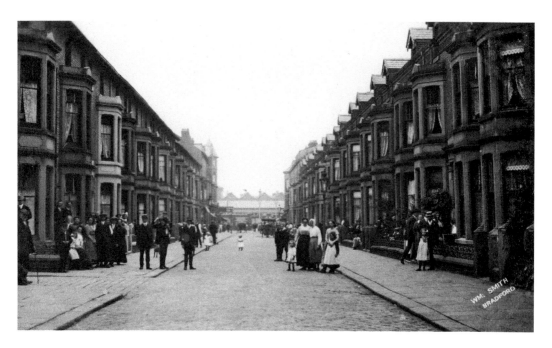

Hull Road

The taking of a street photograph was obviously quite an occasion in the early 1900s in the cobbled Hull Road between Coronation Street and Central Drive. The guesthouse properties in Hull Road, to whom these photographs would be sold so that guests could send home pictures of where they had stayed, were ideally placed to capitalise on the millions of holidaymakers who flowed out of the Central Station terminus (seen in the distance at the bottom of the road) and the proximity of the Tower, the Promenade and the town centre.

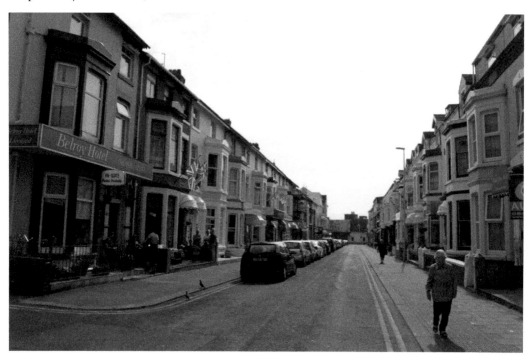

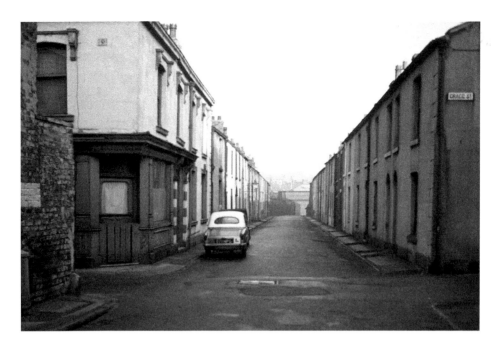

Oddfellow Street, off Bonny Street

Oddfellow Street, looking east from Bonny Street at the rear of the Golden Mile, is seen above in the early 1950s, just before the mid-nineteenth-century property of Bonny's Estate was cleared away. On the left corner 'Our House' Inn is closed and in the distance are the brick abutments of Chapel Street railway bridge and the rear of the King Edward buildings on Central Drive. The area now houses the 'new' Blackpool police headquarters of the Lancashire Constabulary, opened on 21 April 1976, a car park and the Blackpool County Court and Blackpool & Fleetwood Magistrates Court.

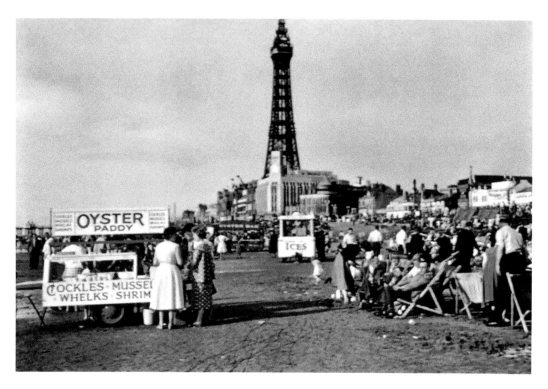

Central Beach

Central Beach opposite the Golden Mile in the 1950s, in the days when the deckchair was king and when people sunbathed with their sleeves rolled up, in long dresses and with their jackets on. The excellent new headland promenade-widening works are now complete and the popularity of this stretch of beach remains. The green-roofed building on the Promenade in the centre of the modern picture is the RNLI Blackpool Lifeboat Station & Visitor Centre, which opened in 1998.

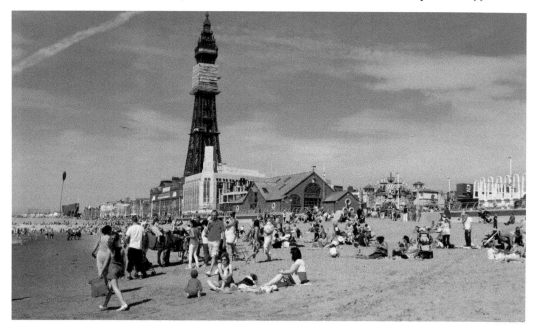

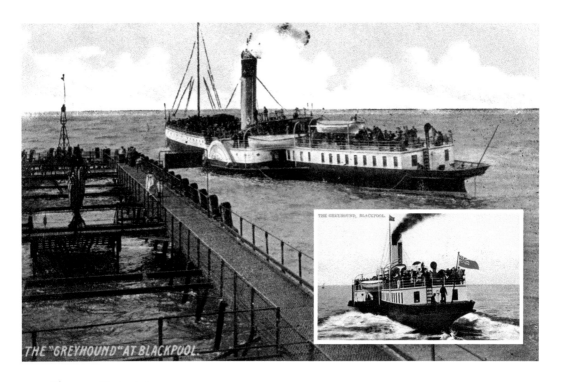

THE "GREYHOUND" AT BLACKPOOL.

Pleasure Steamers

The North Pier jetty extension in 1867 marked the start of an era of pleasure steamers from Blackpool to places such as Morecambe and Llandudno. The *Greyhound*, seen above leaving North Pier, sailed from Fleetwood. It arrived in Blackpool in 1885 and was said to be the finest paddle steamer. In 1895 the *Queen of the North* operated from Central Pier but sank while minesweeping in the North Sea in 1917. Steamboat sailings were abandoned in 1939, and while there have been occasional sailings since the 1960s, no berthing facilities remain.

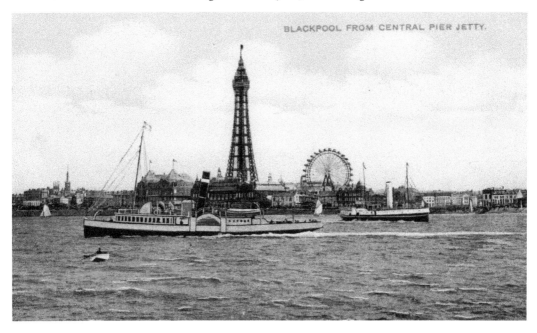

BLACKPOOL FROM CENTRAL PIER JETTY.

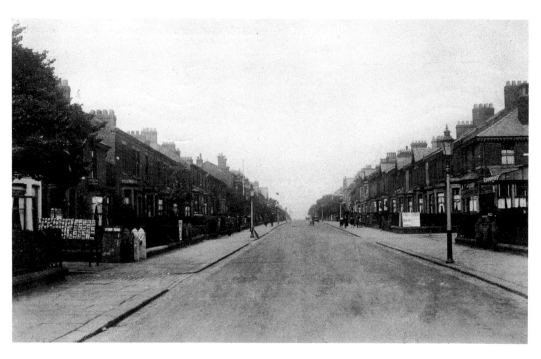

Hornby Road

Hornby Road, looking east from near to the junction of Stanley Road, *c.* 1910. The *Evening Gazette* website tells us that Hornby Road formed part of the motorised 24-seater charabanc tour route between the Tower and Stanley Park in the period 1926–1932. Most (if not all) of the properties on Hornby Road east to Park Road have been converted into guest houses.

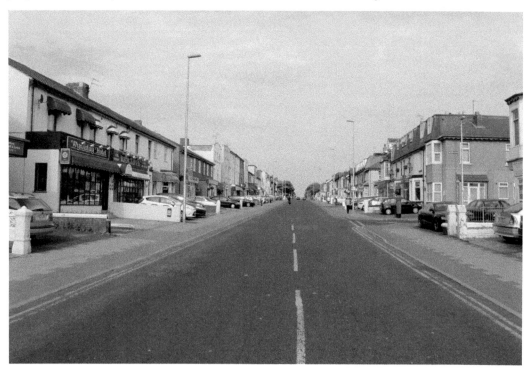

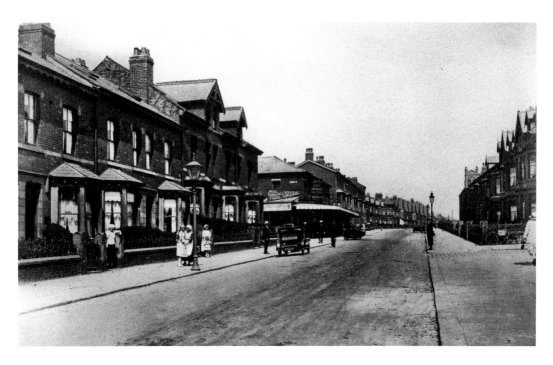

Reads Avenue

Reads Avenue is seen here near its junction with Coronation Street and was named after the Read family who opened Reads Baths on the Golden Mile in 1861, which later became the Luna Park amusement arcade and in modern times was Mr B's. The premises on the corner of Coronation Street is a joiner's/shopfitter's/undertaker's and advertises tyres and Yates, Greer & Co. Ltd (butcher's of 87a Coronation Street). The corner building is now the Hotel & Apartments Social Club. To the right, the tower of the Swedenborgian church of 1910 can be seen.

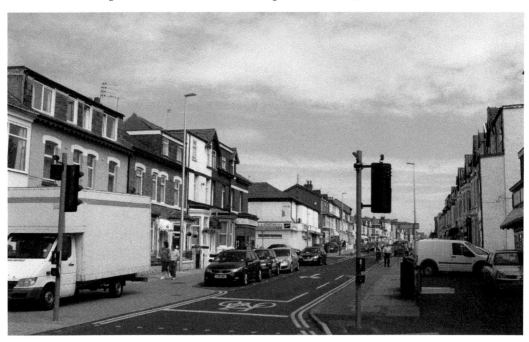

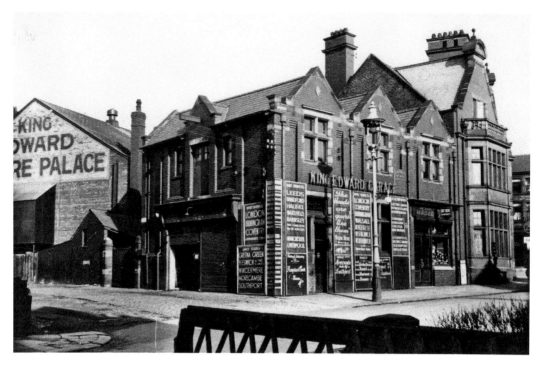

King Edward Garage

The King Edward Garage, the King Edward VII Hotel (1903) and the rear of the Grade II listed King Edward Picture Palace, which opened in 1913 as the Central Picture Theatre, are seen above in the 1940s on the Chapel Street corner of Central Drive. The garage is thought to have been owned by Mr W. C. Standerwick and is the office for excursions and daily services to London, Birmingham and elsewhere, which developed out of the charabanc tours of earlier years. The fare for a day trip to Morecambe in the 1940s would have cost 4s.

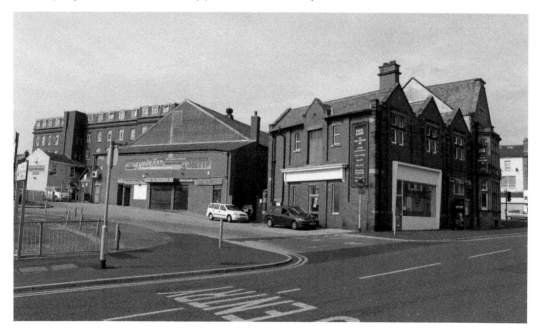

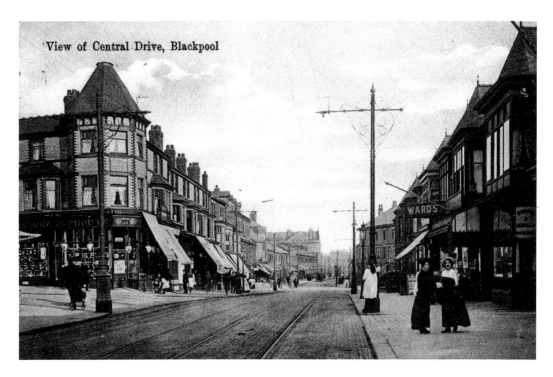

View of Central Drive, Blackpool

Central Drive Looking South from Chapel Street
In 1882 Central Drive ran as far as Revoe Farm (near the site of Revoe Library). This view from around 1905 is looking south into the Revoe area of Blackpool, with Palatine Road on the left, the George Hotel (1893) in the distant centre and Revoe Library further away. It shows how, as a result of the rapid expansion of Blackpool, little remained of the farmland in this area. The tram tracks of the 'Marton Loop' can be seen; the loop opened in 1901 and was discontinued in 1936.

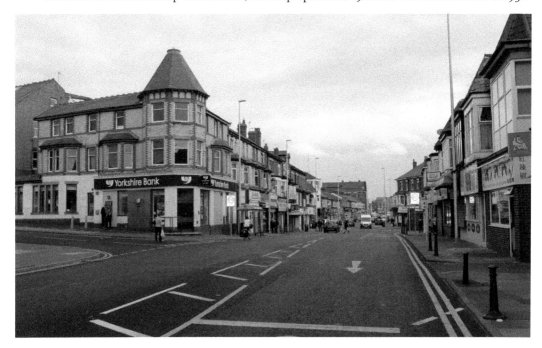

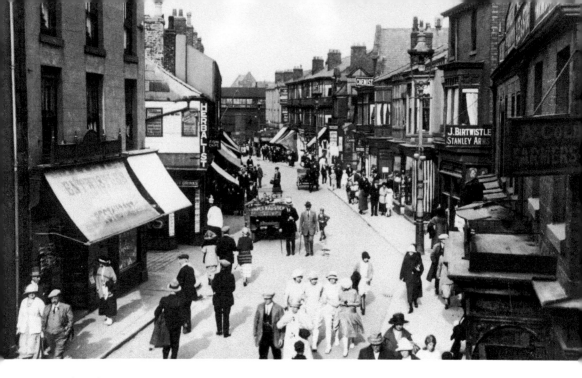

Chapel Street

From medieval times, a track ran from Layton (near the No. 4 pub) to the sea along what is now the line of Chapel Street. The almost traffic-free 1920s photograph above shows the properties that were demolished in the 1960s to make way for the road widening and building of the car park and courts. The Stanley Arms building on the right survives and is now Ma Kelly's Show Bar. The red-brick building in the centre was the Primitive Methodist Church, founded in 1876, and is now the Blackpool Foyer, a support service for young single homeless people that opened in 1999.

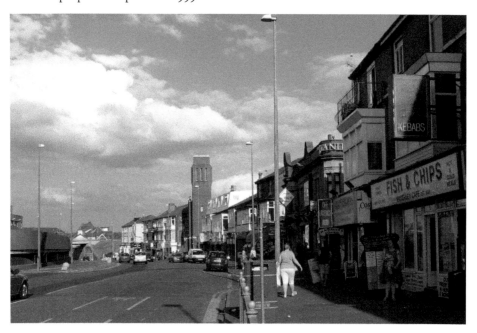

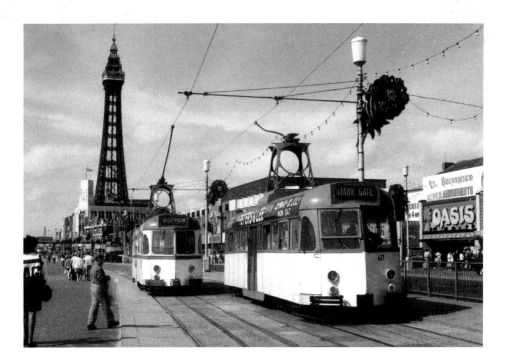

Trams, Central Promenade

In the 1970s view, two Brush Cars dating from 1937 are seen passing on Central Promenade. Brush Car 627 was previously (pre-1968) numbered 290 and was the last car to run on the North Station line. This car is now owned by the Fleetwood Heritage Leisure Trust and has been restored and painted in white and gold for the Queen's Diamond Jubilee. It will be a static exhibit at Pleasure Beach for the 2012 illuminations display. The £100 Million tramway improvement scheme included the replacement of 11 miles of track and the building of a new tram depot at Starr Gate. The new Bombardier Flexity 2 trams became operational on 4 April 2012.

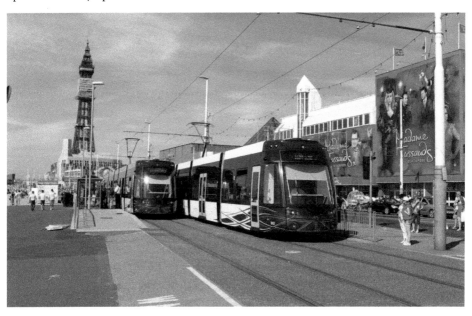

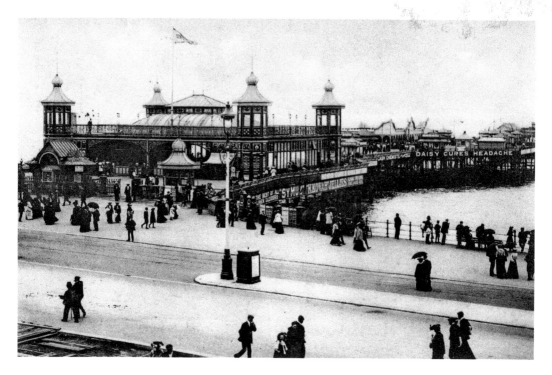

Central Pier

Central Pier opened on 30 May 1868 as South Pier and became known as 'The People's Pier' due to open-air dancing to a band and roller-skating. Its name changed to Central Pier in 1893 when the Victoria (South) Pier was opened. The pier is seen above around 1910 with its pavilion (1903). Amusement machines and rides were introduced in the early twentieth century. The pavilion was demolished in 1967 to make way for the Dixieland Palace, and in 1986 it became Maggie Mays. The 33-metre-high Ferris wheel was added in 1990.

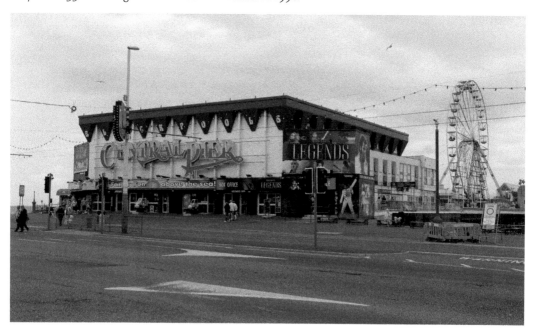

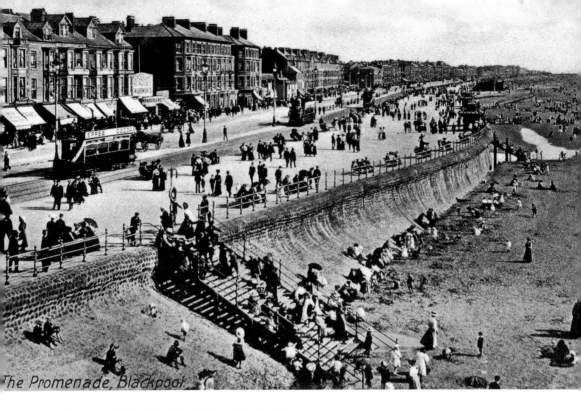

The Promenade, Blackpool.

Promenade Looking South from Central Pier

The newly widened Promenade (1904/05) allowed the tramway to be moved off the road and gave visitors a broad, safe area to walk and enjoy the air and the view. The new sea wall also gave much greater protection from the sea to the shops and properties along the Promenade. Yorkshire House (later York Hotel) stood on the corner of what is now Yorkshire Street until the 1870s. In the centre is the Foxhall Hotel, which was the site of the first substantial building in Blackpool, dating from the late seventeenth century. A century later, the Promenade has again been widened and improved.

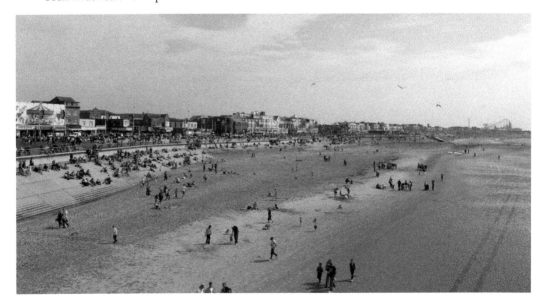

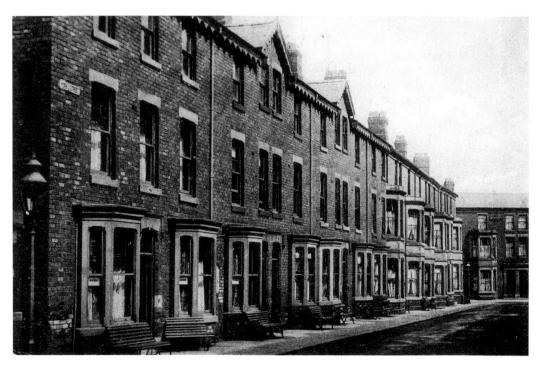

York Street

York Street is seen above around 1915, looking east to Caroline Street from near the junction of Singleton Street (previously East Warbrick Street). The 2012 view of a much brighter York Street with painted frontages was taken just after the street's Diamond Jubilee celebrations in June 2012, and the bunting still remains.

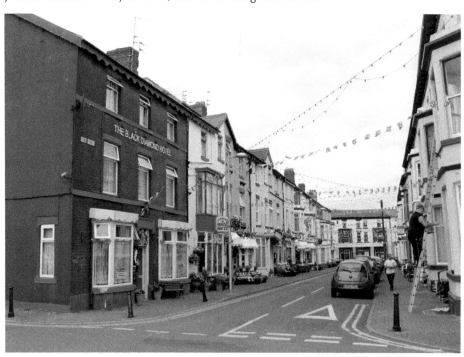

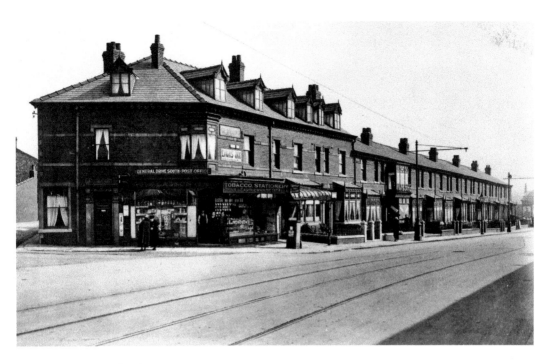

Revoe, Central Drive

The older postcard view of Central Drive near the junction of Grasmere Road (*c.* 1915) shows the extended road, built in the 1890s with its Marton Loop tram tracks, and Central Drive South post office. The wider modern view shows Revoe Library building, opened on 23 July 1904 on what was the site of Revoe Farm.

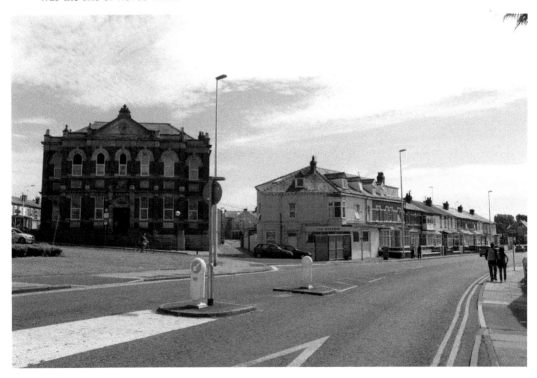

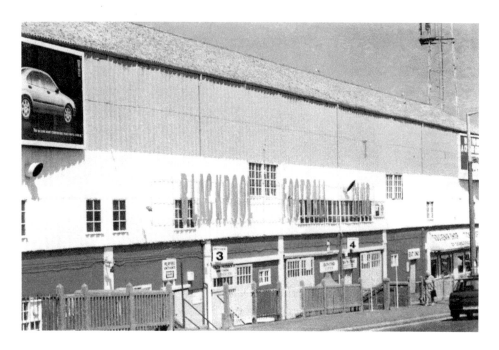

Old South Stand, Bloomfield Road

Blackpool Football Club was founded on 26 July 1887 and moved to Bloomfield Road in 1901 after some time at Raikes Hall Gardens and then at the Stanley Park Athletic Ground, near the present cricket club. Founder members of the Lancashire League in 1889, the club joined the Football League's Second Division in 1896. The 1953 FA Cup Final was the club's finest moment, although the promotion to the Premier League after the win against Cardiff at Wembley on 22 May 2010 was said to be worth £90 million. The old South Stand (1925) was demolished in 2003. The new Jimmy Armfield Stand was built in 2010 and a bronze statue was unveiled on 1 May 2011.

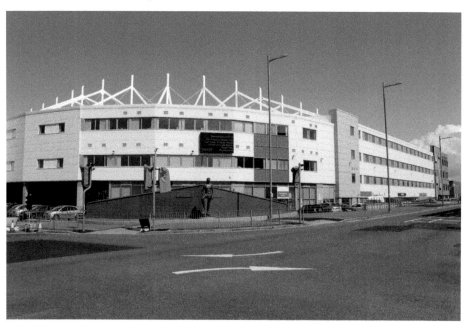

Blackpool's Football Heroes

Sir Stanley Matthews (*right*): Stoke City, Blackpool and England, and played his last top level game at the age of fifty. he was considered by some to be the greatest footballer ever. Stan Mortensen (*bottom right*): Blackpool and England, scored a hat-trick in the 1953 'Matthews' Cup Final. Jimmy Armfield CBE, DL (*bottom left*): played 627 games for Blackpool between 1954 and 1967, mostly at right back. He represented England on forty-three occasions and was captain fifteen times. Injured for the 1966 World Cup, he received his winner's medal in 2009. Tony Green (*inset*): Blackpool (1966–71), Newcastle United and Scotland. He suffered a cartilage injury that ended ended his career at the age of just twenty-five.

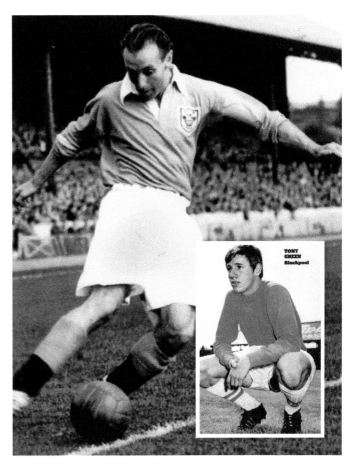

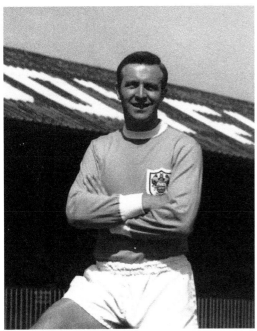

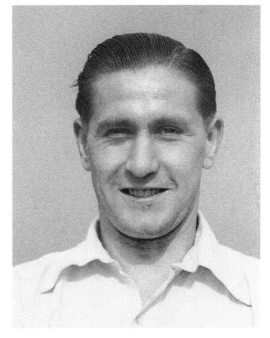

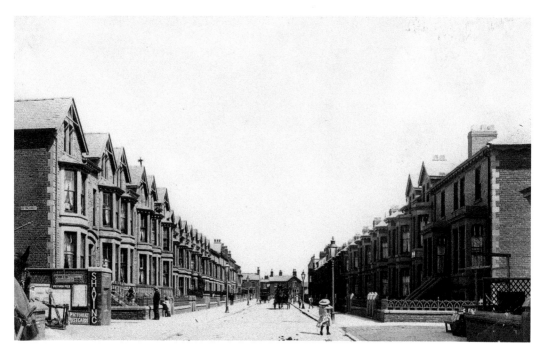

St Chad's Road

St Chad's Road was previously named Springfield Road and is seen here looking east towards Lytham Road from near the Promenade and the corner of Bolton Street, around 1910. Like many Blackpool 'guest house' streets, little has changed other than extensions to the front and roof, the number of cars parked outside and the need for one-way streets.

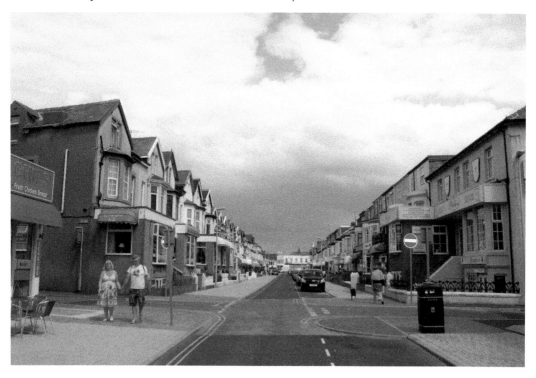

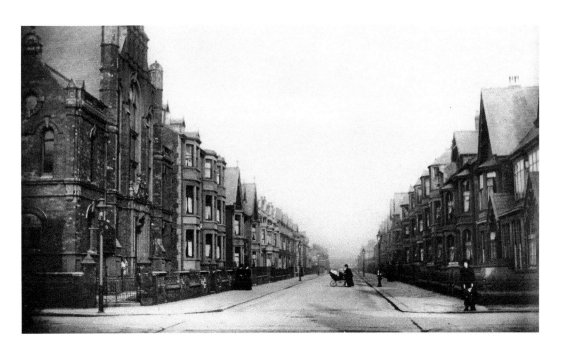

Alexandra Road

Alexandra Road looking east from Bolton Street, around 1910. The Congregational Church to the left was founded in 1890 and the Gothic stone church seen here was opened in 1908. The church had seating accommodation for 650. In 1972 the Congregational Church joined with the English Presbyterian Church to become the Alexandra United Reformed Church on Bolton Street. The site of the church has been redeveloped as housing, known as Alexandra Court, and the properties in Alexandra Road have generally been converted to hotels and boarding houses.

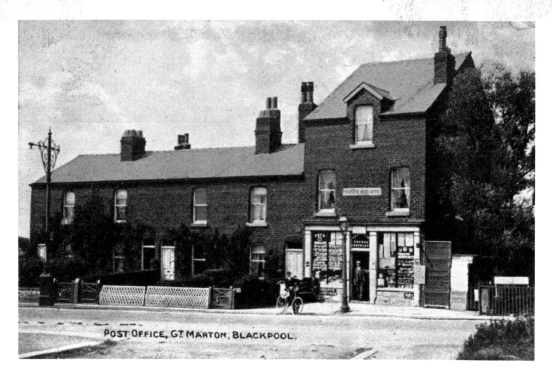

POST OFFICE, GT MARTON, BLACKPOOL.

Great Marton Post Office

The original Great Marton post office, in the postcard view above, was located on the north side of Cow Gap Lane (now Waterloo Road) between the Oxford public house and Cow Gap Bridge (Spen Corner). It opened in 1885 and moved further up the road in 1890 to the corner of Vicarage Lane. No. 374 Waterloo Road is now occupied by Blackpool Sunbeds.

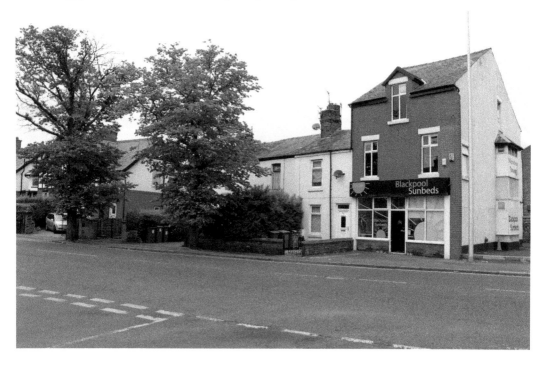

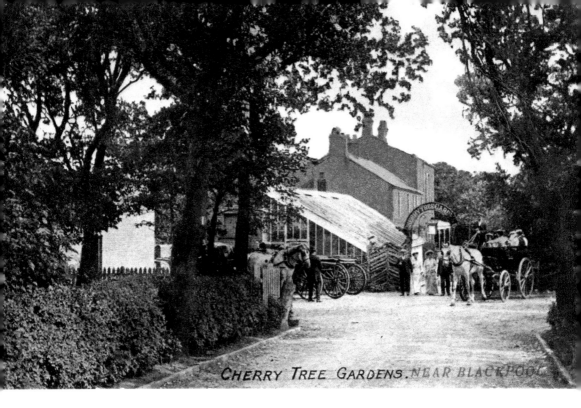

CHERRY TREE GARDENS. NEAR BLACKPOOL

Cherry Tree Gardens

The Cherry Tree Gardens Hotel in Marton 'near Blackpool' wooed visitors away from the Promenade on charabanc trips with luncheons, teas, dancing and its gardens. In the 1960s it was the UK home of 'Your Father's Moustache', with banjo/umpah band entertainment. The site has been redeveloped as supported housing for older people. On the right of the modern picture is Tulluch Court, completed in 2010 and providing 'extra care' apartments.

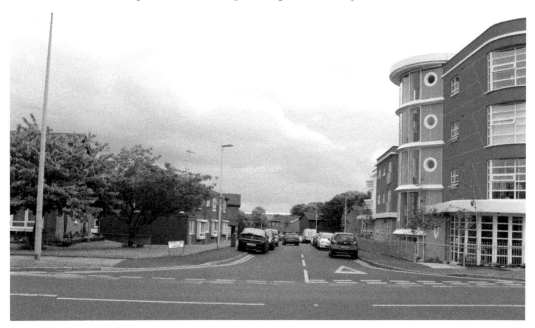

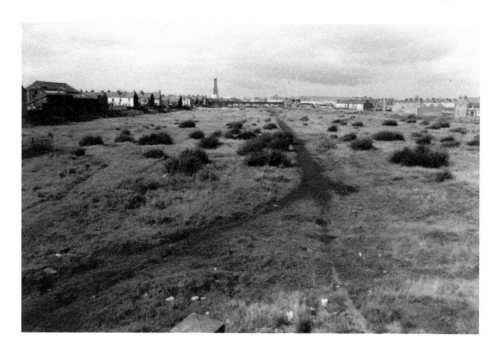

Old Railway Land from Waterloo Road Bridge, Cow Gap Lane

When the railway was extended in 1863, the two lines to Central Station were located close to the houses to the left. Over the following years this whole area was covered in railway lines and sidings. In 1898, this view from Cow Gap Lane would have looked into the football ground of South Shore FC, who played Newton Heath (later Manchester United) there on 28 October 1898, winning the FA cup tie 3–1. The picture taken in the 1980s from Waterloo Road Bridge is of the disused 'railway land' before it was developed into the Blackpool car and coach park, with direct access to the M55. The 2012 view shows the recently completed transformation, which included the removal of Bloomfield Road Bridge.

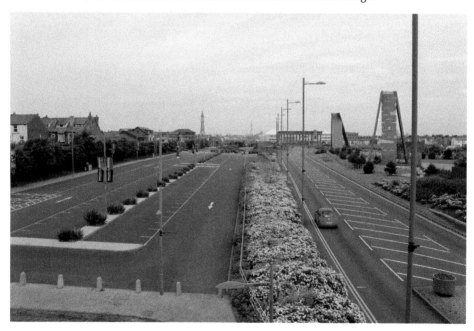

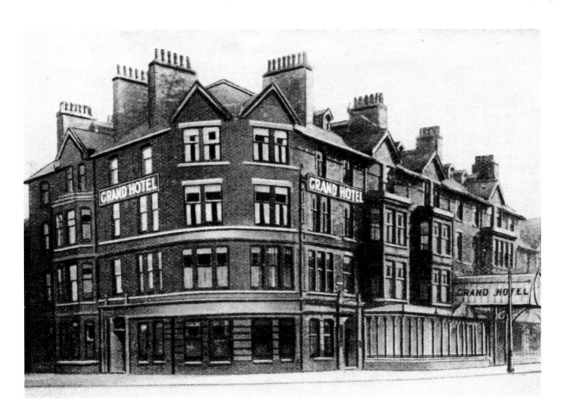

The Grand Hotel, Station Road

This photograph of the Grand (as it was called) was taken from the 1935 edition of the annual *Blackpool Holiday Journal*. The six-storey hotel, on the corner of Station Road and Lytham Road, originally had sixty bedrooms, all fitted with hot and cold water, but it had been converted into a pub with some fifty-two self-catering apartments in recent years and closed in 2008. The property was for sale when it burnt down on 28 July 2009 and was subsequently demolished. The site has not yet been redeveloped.

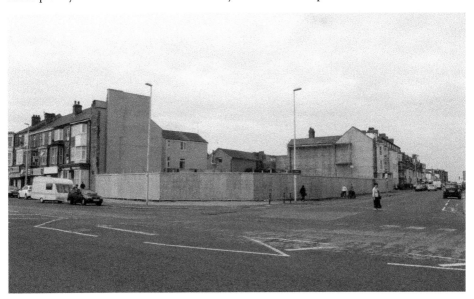

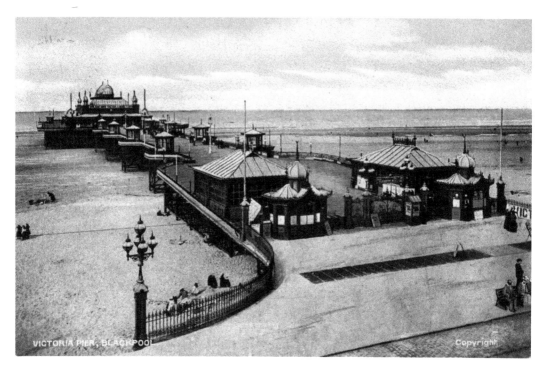

Victoria Pier (South Pier)

Victoria Pier, the third of Blackpool's piers, was built by the Blackpool South Shore Pier & Pavilion Co. Ltd in the rapidly developing South Shore area and opened on Good Friday 1893. At 489 feet in length it is the shortest of the three piers. The Grand Pavilion held brass band and classical concerts and seasonal shows. It was demolished in 1998. The pier changed its name to South Pier in 1930 and is now occupied by amusement stalls and rides.

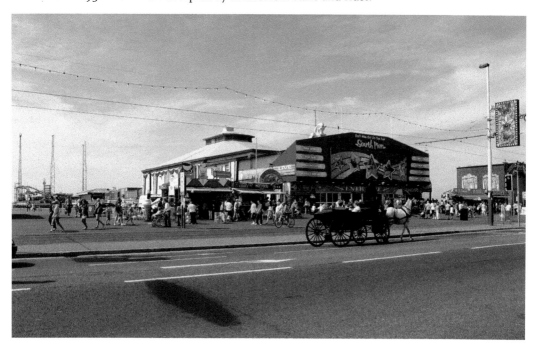

I AM HAVING THE COBWEBS
BLOWN OUT OF MY BRAINS
AT BLACKPOOL

Comic Postcards

Picture postcards first went on sale in Britain
the late 1890s. At that time the postcard was
smaller in size and the message was to be
written on the same side as the picture. The
most popular postcards were those with beach
and Promenade views, and many people sent
cards of the hotel or guesthouse they were
staying in. Comic and 'saucy' postcards were
also very popular. In the early years some
of these were considered to be obscene and
shopkeepers could be prosecuted.

JUST A LINE FROM BLACKPOOL.

WE ALL GO THE SAME WAY HOME.

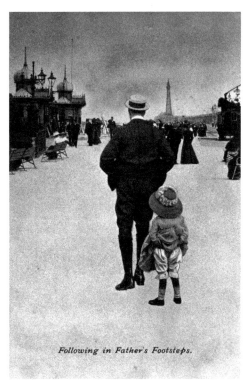

Following in Father's Footsteps.

Sight Seeing at Blackpool

89

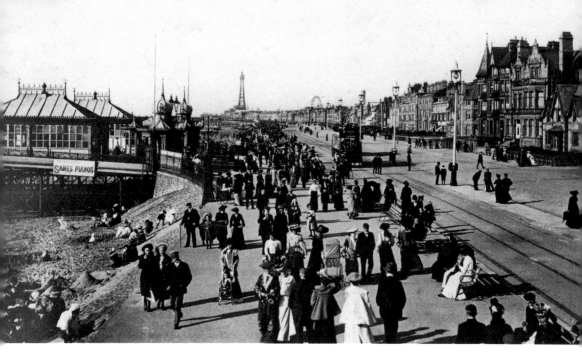

South Pier, Looking North

This postcard view, posted in 1909, was taken prior to the widening of the entrance to Victoria Pier (South Pier) in 1902 and captures the popularity of strolling along the Promenade in hats and coats. At this time the trams terminated at the Pleasure Beach. They were extended to Starr Gate when the New South Promenade was opened in 1926.

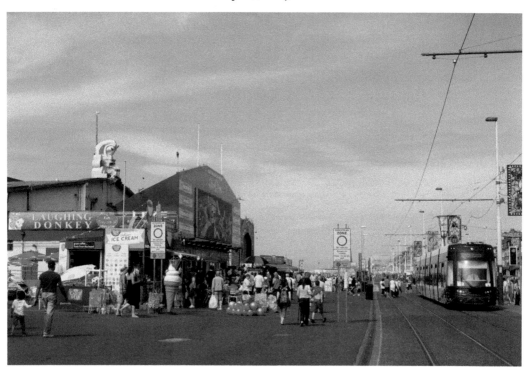

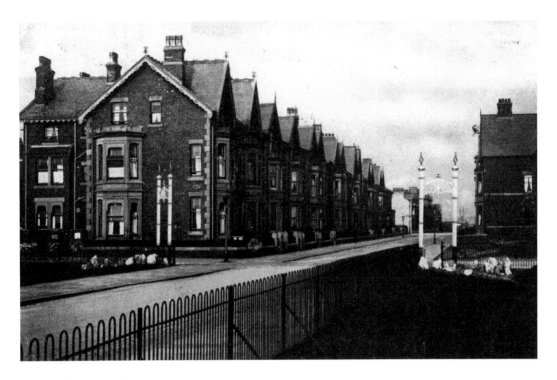

Osborne Road

As Blackpool developed southwards in the 1890s, Victoria Pier opened (1893) and the fairground on the beach at South Shore became the Pleasure Beach (1906). As a result, boarding house properties were built to cater for the growing popularity of this area. The gardens either side of Osborne Road between the Promenade and Simpson Street, seen in this 1918 postcard view, have been commercialised and to the left is a 'golf putting' attraction.

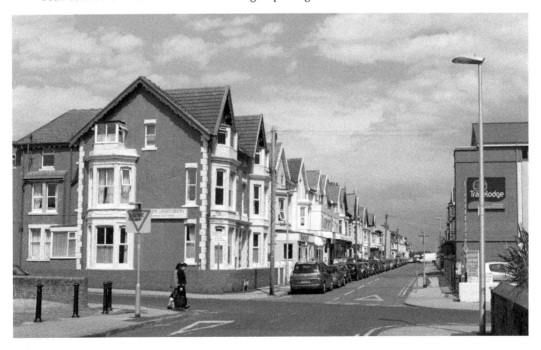

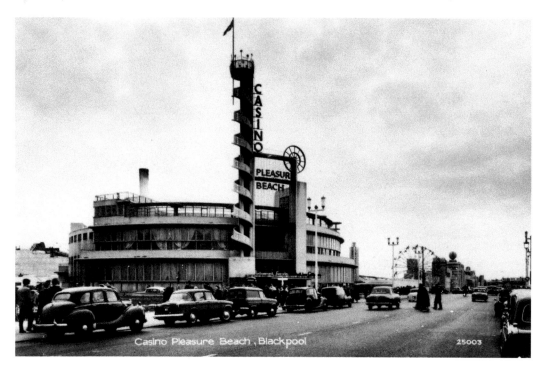

Casino Pleasure Beach, Blackpool 25003

The Casino, Pleasure Beach

The introduction of the modernist style of building throughout the Pleasure Beach was due to the engagement of architect Joseph Emberton in 1933 by Leonard Thompson, then the Managing Director of the Pleasure Beach. An earlier 'wedding cake' style Casino had been built in 1913. It was demolished in 1937 to make way for the modernist circular, reinforced-concrete building, which was built to Emberton's designs. Despite the name of the first and the current buildings, gambling has never been part of the facilities at the Casino.

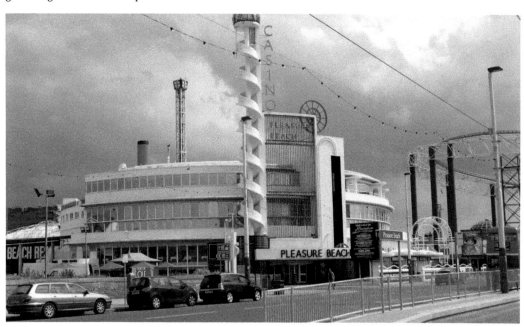

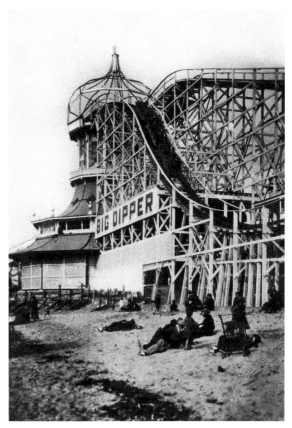

The Big Dipper, Pleasure Beach
The Big Dipper, which opened on
23 August 1923 on the beach at
South Shore, is a classic wooden
rollercoaster. It was redesigned and
extended in 1936. Between 1922 and
1926 the land in front of the Big
Dipper was reclaimed and the New
South Promenade to the southern
boundary was constructed. The area
between the Big Dipper and the
Promenade was used as a boating lake
for many years and is now the site
of the originally-named Pepsi Max
'Big One' (steel rollercoaster), which
opened on 28 May 1994.

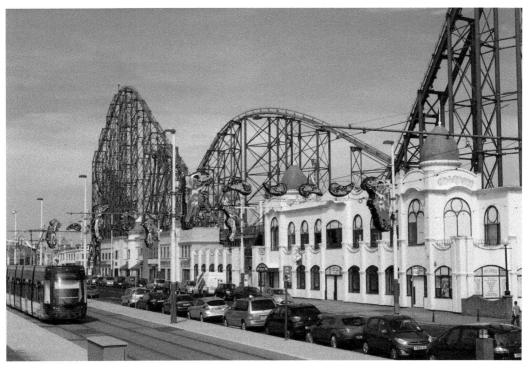

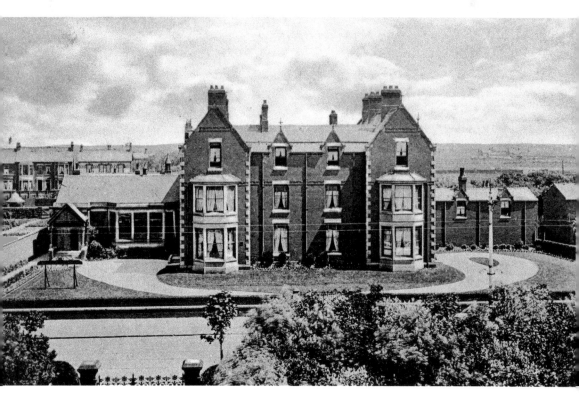

Arnold School

Arnold School was founded on 4 May 1896. It was named after Dr Thomas Arnold, Headmaster of Rugby School. Arnold Girls' split from the main school in the 1940s and moved to Bispham. There have been many developments to the school on Lytham Road and it has now merged with King Edward VII & Queen Mary School and is named Arnold KEQMS School.

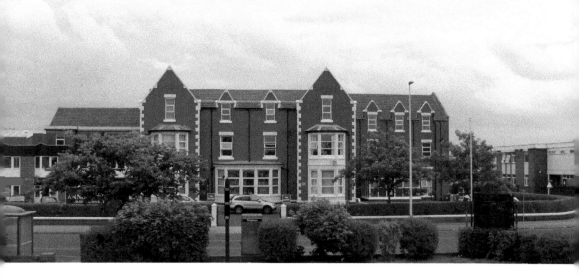

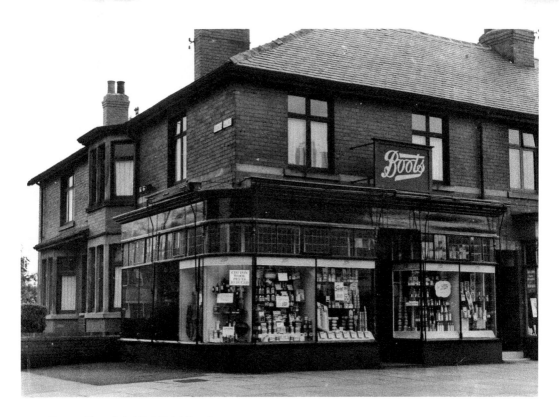

Boots Chemist, Highfield Road

Boots was founded in Nottingham in the 1870s by Jesse Boot. By 1933 the company had 1,000 shops in the UK. The Boots shop at 49 Highfield Road on the corner of Orchard Road, seen above around 1950, is now occupied by Totesport. Next door, the Willows offered a shoe repair service and is now the Willows Coffee House.

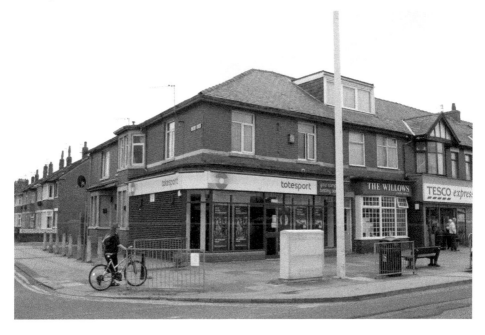

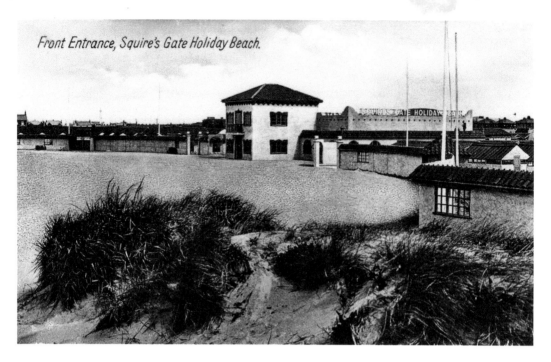

Front Entrance, Squire's Gate Holiday Beach.

Squires Gate Holiday Camp

Just outside the Blackpool Borough boundary, south of Squires Gate, this area was used as a tented holiday camp in the 1930s and opened as Squires Gate Holiday Camp in 1937. The brochure (*inset*) states that Ration Books must be brought for each person. In the 'Special Carnival Week' of 30 July to 6 August 1949 the cost was £6 10s for an adult and £3 5s for a child between the ages of five and twelve. The camp was bought by Pontins in 1961 and closed on 2 October 2009. The site has largely been cleared and is to be redeveloped for housing.

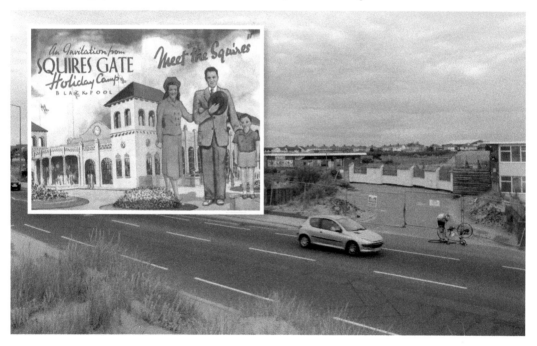